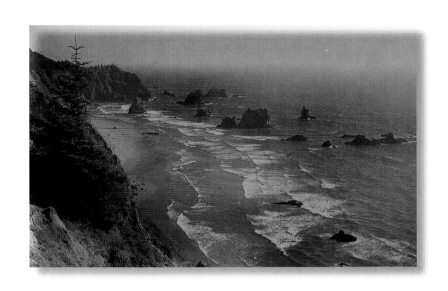

OREGON

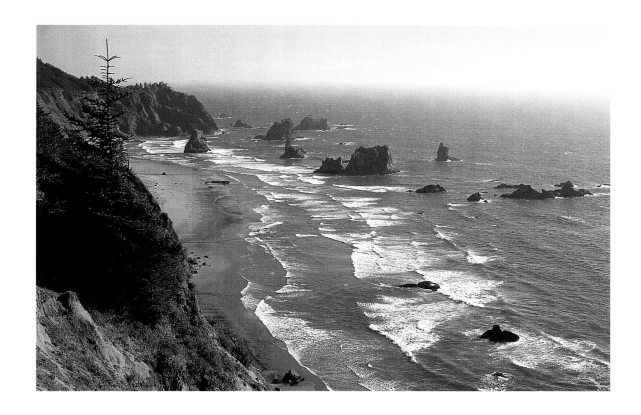

whitecap

The information in this book is true and complete to the best of the author's knowledge.
All recommendations are made without guarantee on the part of the author or Whitecap
Books Ltd. The author and publisher disclaim any liability in connection with the use of
this information. For additional information please contact Whitecap Books Ltd., at 351
Lynn Avenue, North Vancouver, British Columbia, Canada V7J 2C4

Text by Tanya Lloyd Kyi
Edited by Elaine Jones
Proofread by Lisa Collins
Cover and interior design by Steve Penner
Front cover photograph of Samuel Boardman State Park
 by Thomas Kitchin / First Light
Back cover photograph of Portland and Mount Hood
 by Josemaria Toscano / Shutterstock.com

Printed and bound in China by 1010 Printing Asia Ltd.

Library and Archives Canada Cataloguing in Publication

Lloyd, Tanya, 1973 –
 Oregon

 ISBN 1-55110-864-X
 ISBN 978-1-55110-864-3

 1. Oregon—pictorial works. I. Title.

F877.L66 1999 979.5'043'0222 C98-911021-4

The publisher acknowledges the financial support of the Government of Canada through
the Canada Book Fund (CBF) and the province of British Columbia through the Book
Publishing Tax Credit.

For more information on the America series and other titles by Whitecap Books,
please visit our website at www.whitecap.ca.

About 6,600 years ago, a volcanic peak known as Mount Mazama erupted, spewing lava and collapsing inward. The event created a giant caldera, and over the next three centuries, this depression filled with water. It eventually reached a depth of 1,932 feet. Today, this site is known as Crater Lake, a crystal blue jewel covering more than 20 square miles. The site draws thousands of visitors each year.

Oregon is known around the world for its array of natural wonders—the Columbia River Gorge, the spectacular coastline, rich fossil beds, and tumbling waterfalls. For many, the history of the state begins with the pioneers. They think of the arrival of Lewis and Clark at the mouth of the Columbia, or the boom of settlers who followed the Oregon Trail in the last century. In reality, the state's dominating characteristics— its jagged shores and rugged mountains—were formed thousands of years ago.

Like the volcanoes of the Coast Range, the last ice age left its mark. Melting glaciers and ice fields created scouring floods and sent massive rivers churning toward the coast. One such river gouged the crevasse we now know as the Columbia River Gorge. Even the gently rolling geography of the Oregon Dunes was created by dramatic geologic events. Scientists believe that an area of rock and ash escaped volcanic activity and was pushed into the ocean. The ancient shelf is swept back to shore by the tides, creating constantly growing dunes.

The state is filled with magnificent settings formed by the volcanoes, earthquakes, and glaciers of the past. Some of these events created the rich soil that now makes the state one of the most agriculturally diverse in the nation. Others carved the rugged offshore islets that characterize the coastline. In this book, some of North America's top photographers have captured these places, revealing the array of attractions within Oregon's borders.

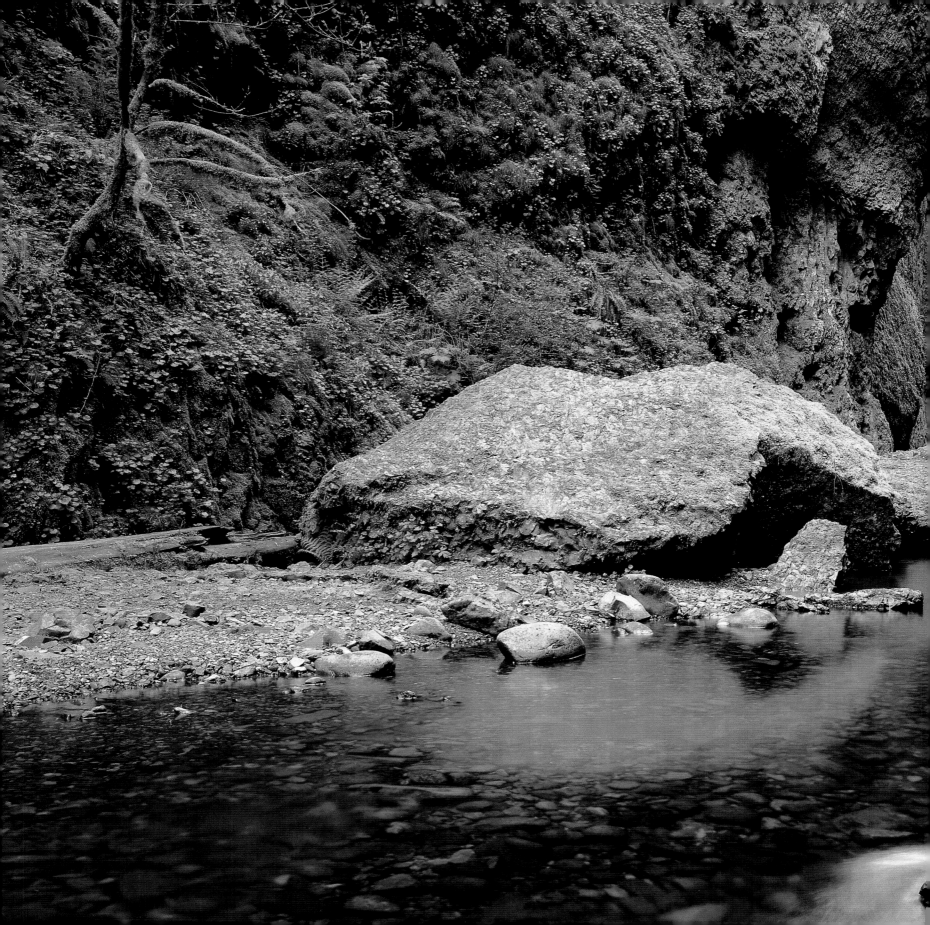

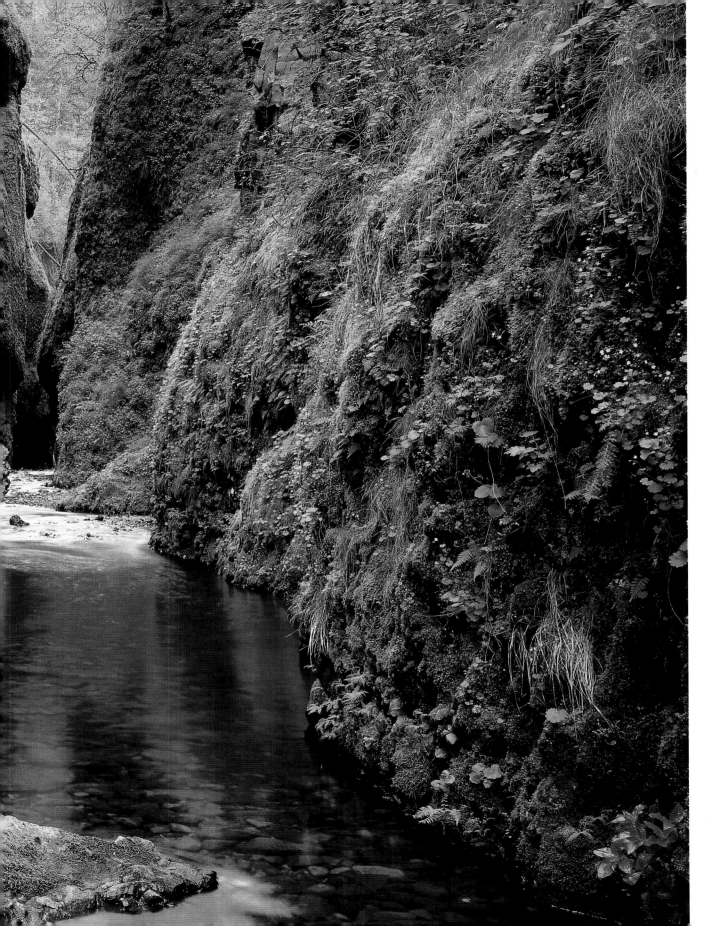

The lush vegetation of the Oneonta Gorge includes plants found nowhere else in the state. The canyon's towering walls preserve a damp, mossy microclimate.

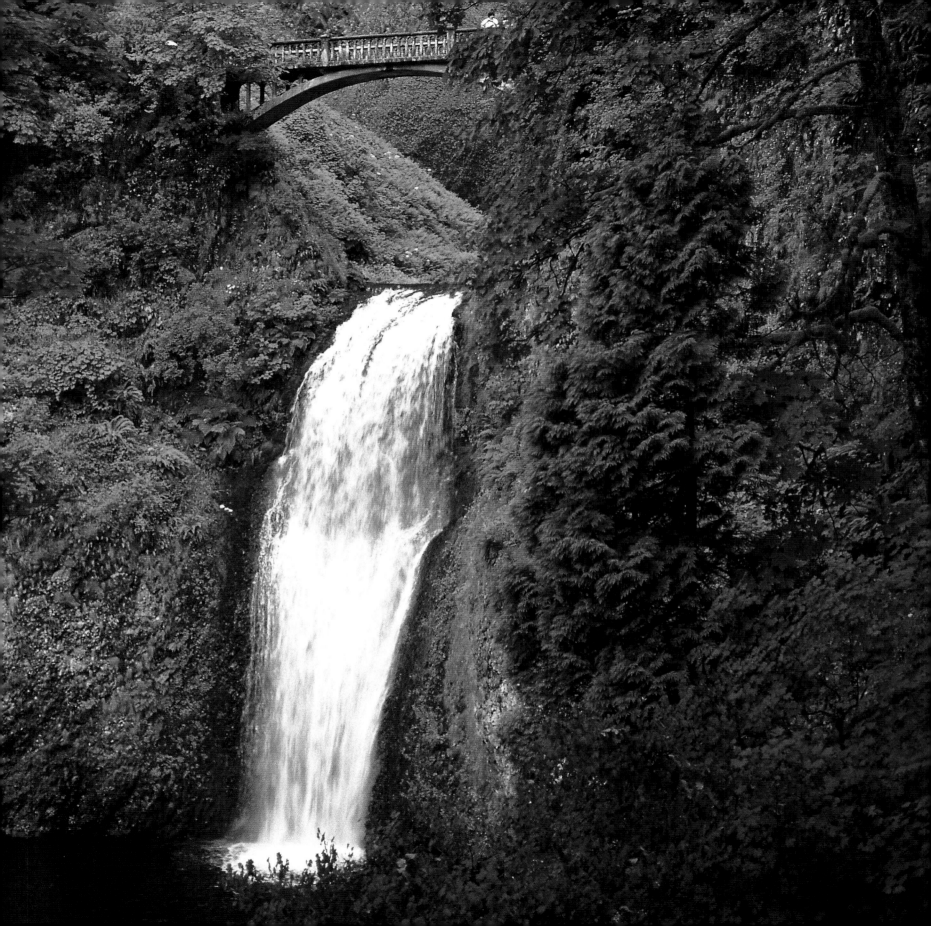

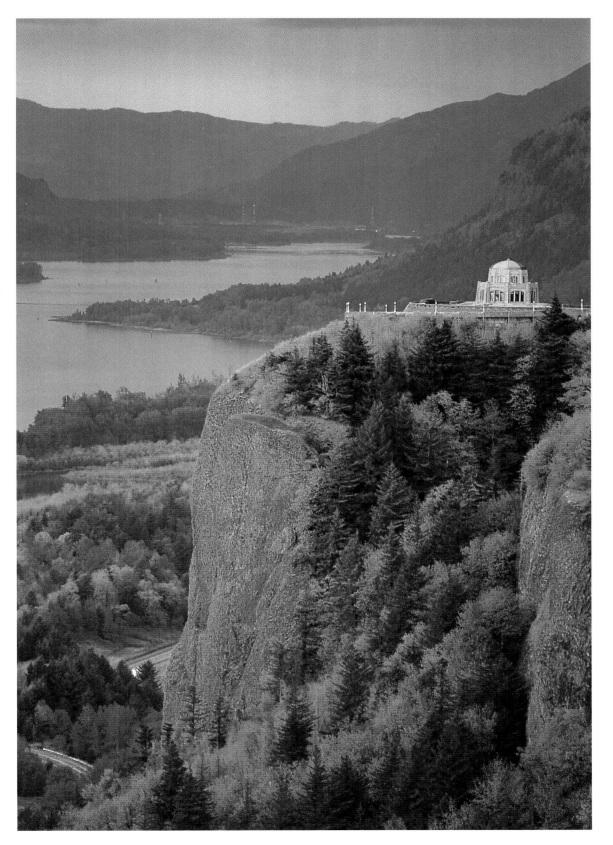

Vista House at Crown Point, built in 1916, was part of a plan by highway engineer Samuel Lancaster to introduce people to the wonders of the Columbia River Gorge. It now serves as an interpretive center, offering information on the region.

OPPOSITE—
With an upper waterfall of 541 feet and lower drop of 69 feet, Multnomah Falls is the fourth highest in America. It is believed to be named after a native chief from the Willamette Valley.

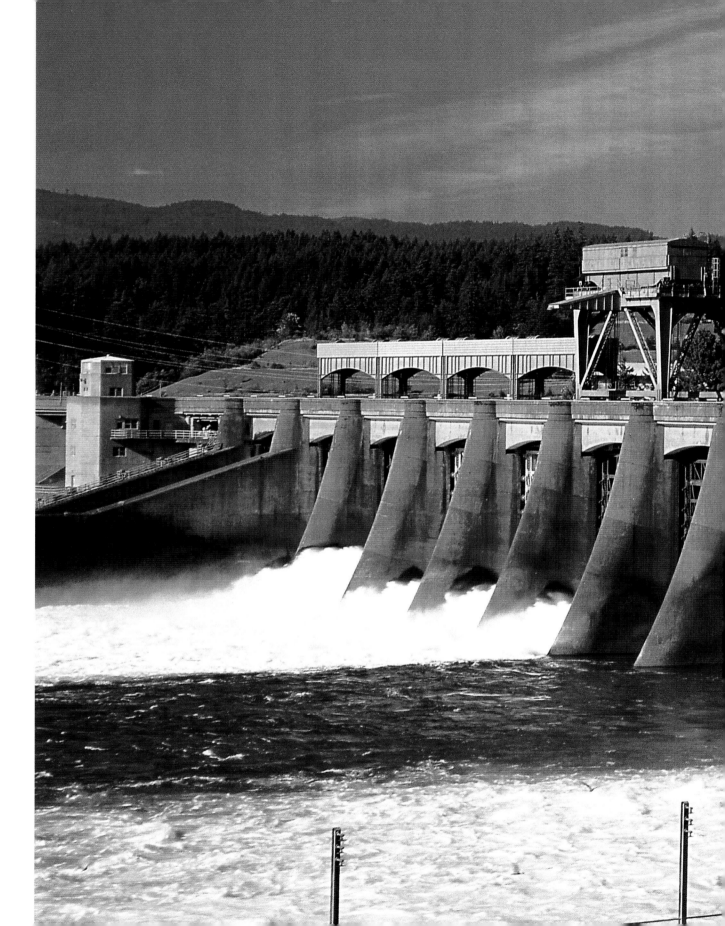

About 40 miles east of Portland, the Bonneville Dam has been churning out power since 1938, when it became the first dam on the Columbia River. It stretches 3,460 feet across the river and can provide electricity for about 20,000 homes.

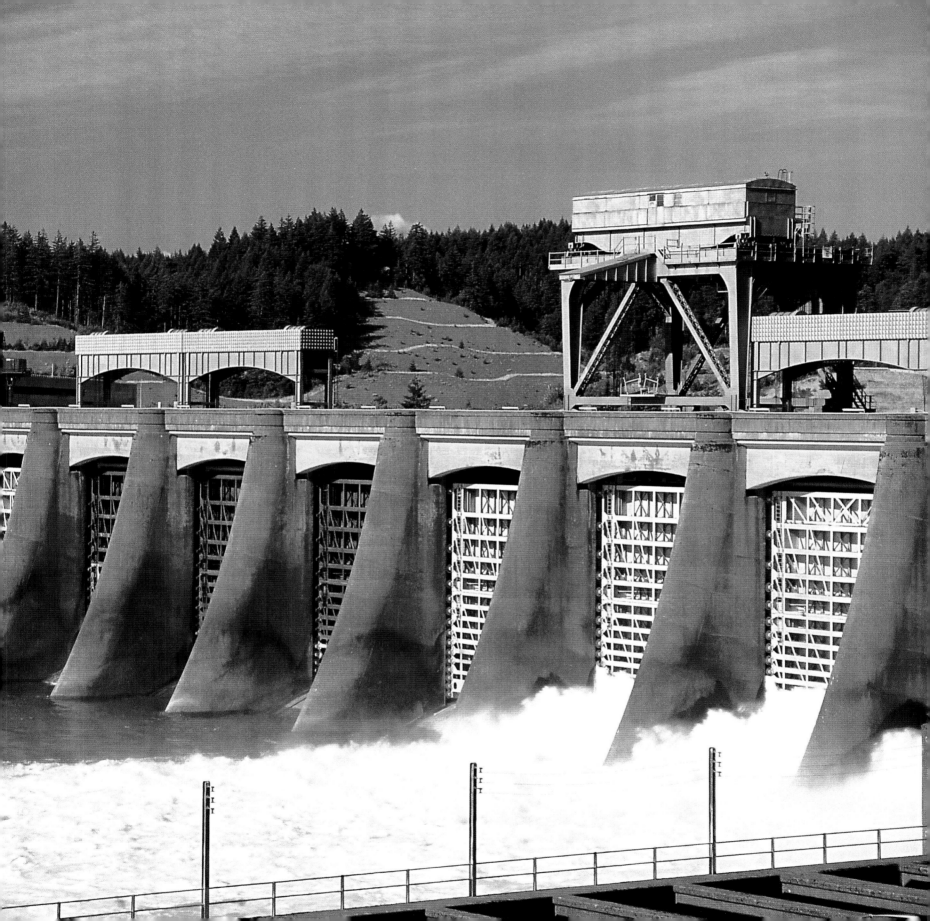

Latourell Falls is one of about 70 waterfalls that pour over the cliffs of the Columbia River Gorge.

OPPOSITE—
The Bridge of the Gods spans the Columbia River between Oregon's Cascade Locks and Washington. According to native legend, a natural stone bridge once spanned the river at this site.

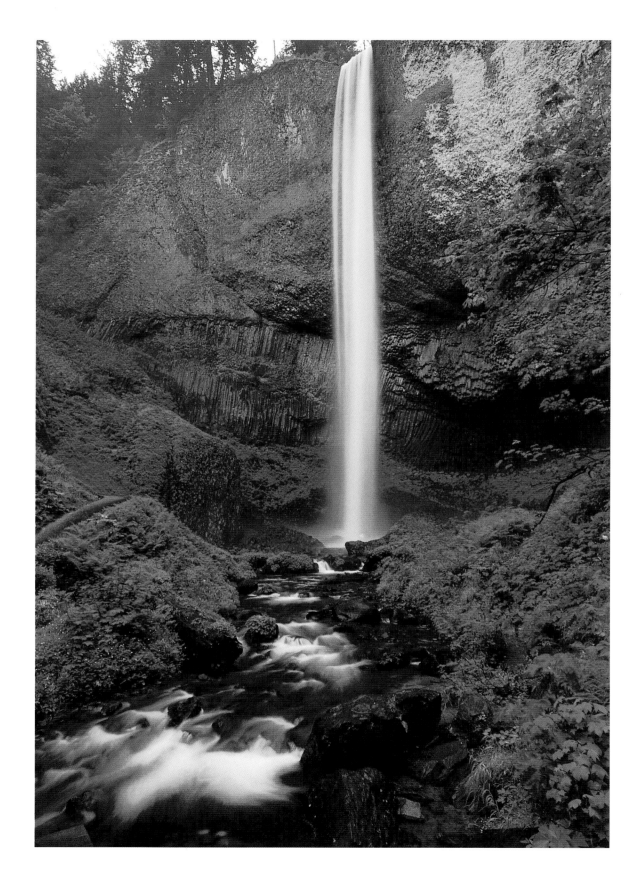

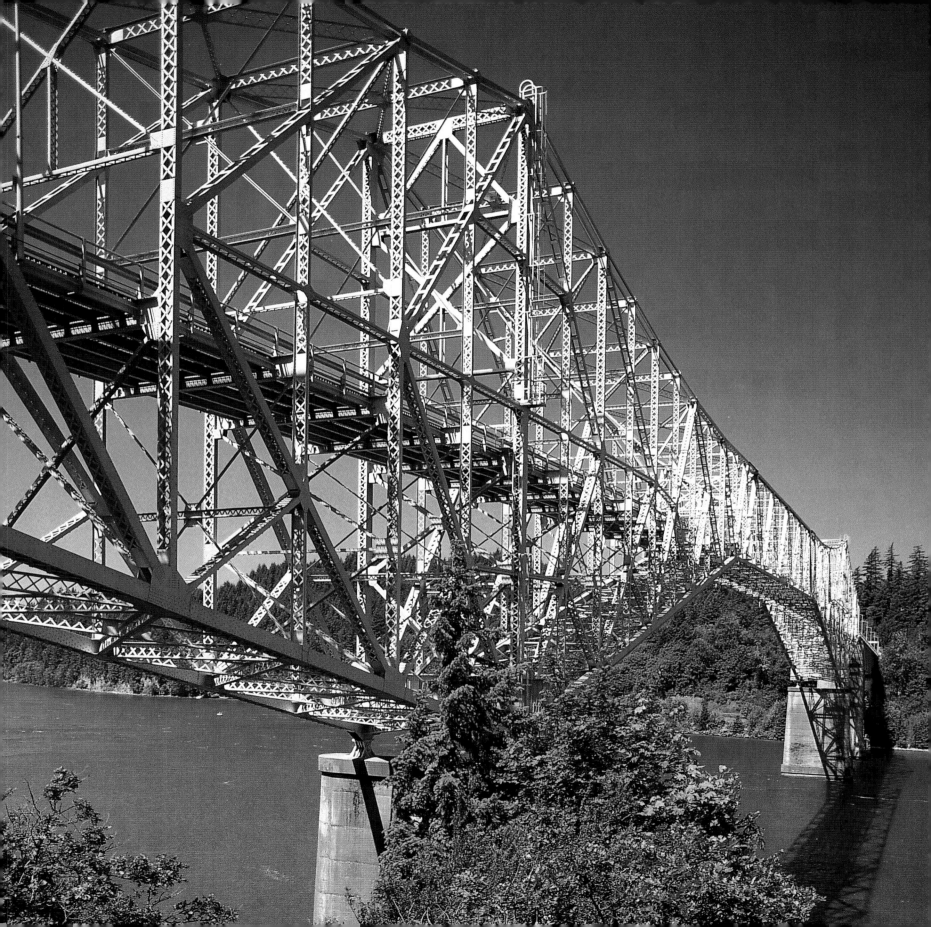

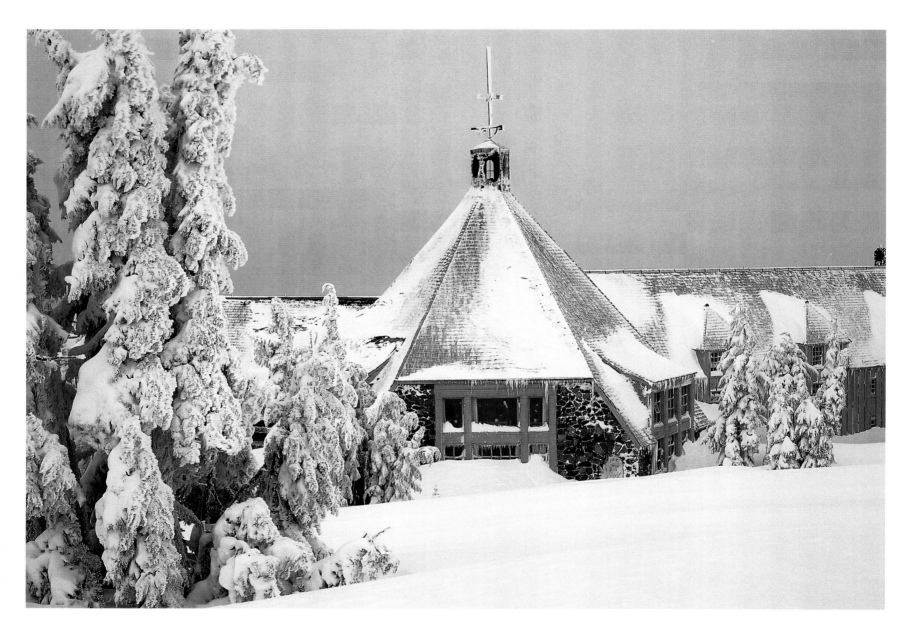

Lifts at Timberline Ski Area run year round, carrying enthusiasts up the slopes of Mount Hood. Timberline Lodge, famous for both its art displays and its role in the film *The Shining,* was built in the 1930s.

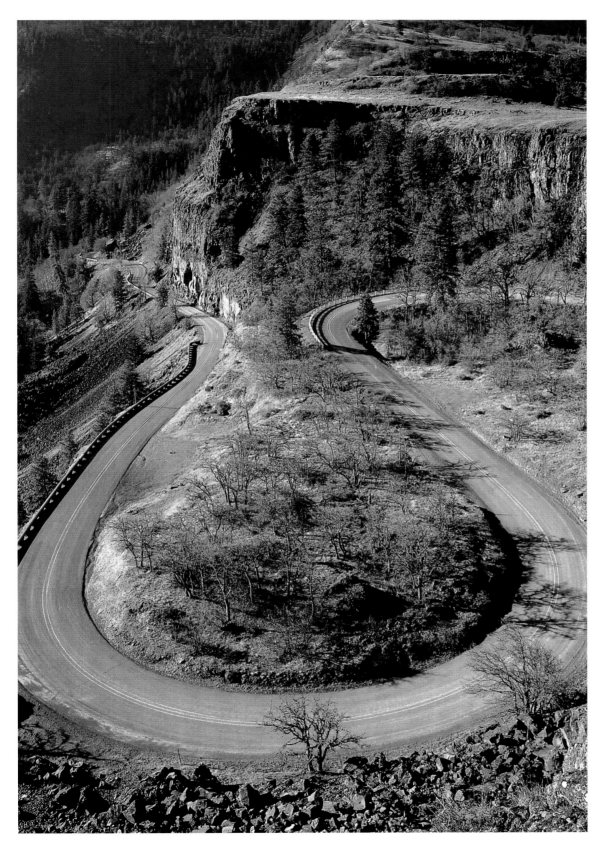

In 1805, Thomas Jefferson sent explorers Meriwether Lewis and William Clark to gather data on the continent and search for an all-water fur-trading route across America. They traced the Missouri River, traversed the Rockies, and journeyed down the Columbia River to the Pacific. This scene shows some of the difficult terrain in Oregon. Today, travel in these areas is eased with well-maintained highways and secondary roads.

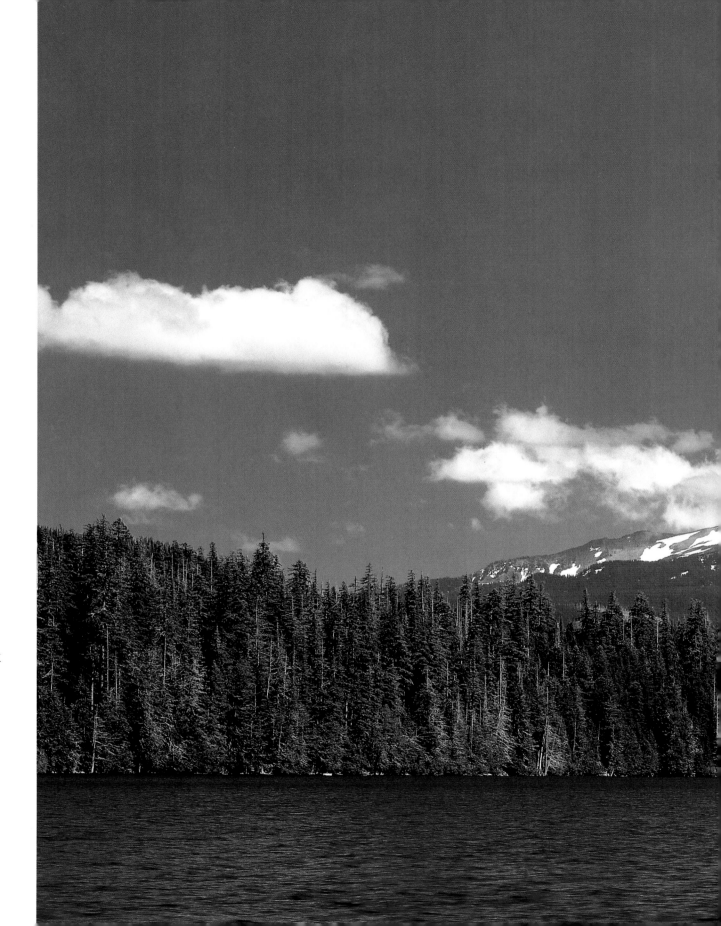

Mount Hood is
Oregon's highest peak
and attracts more
climbers than any
other glaciated peak
in North America.
In the world, only
Japan's Mount Fuji
draws more.

16

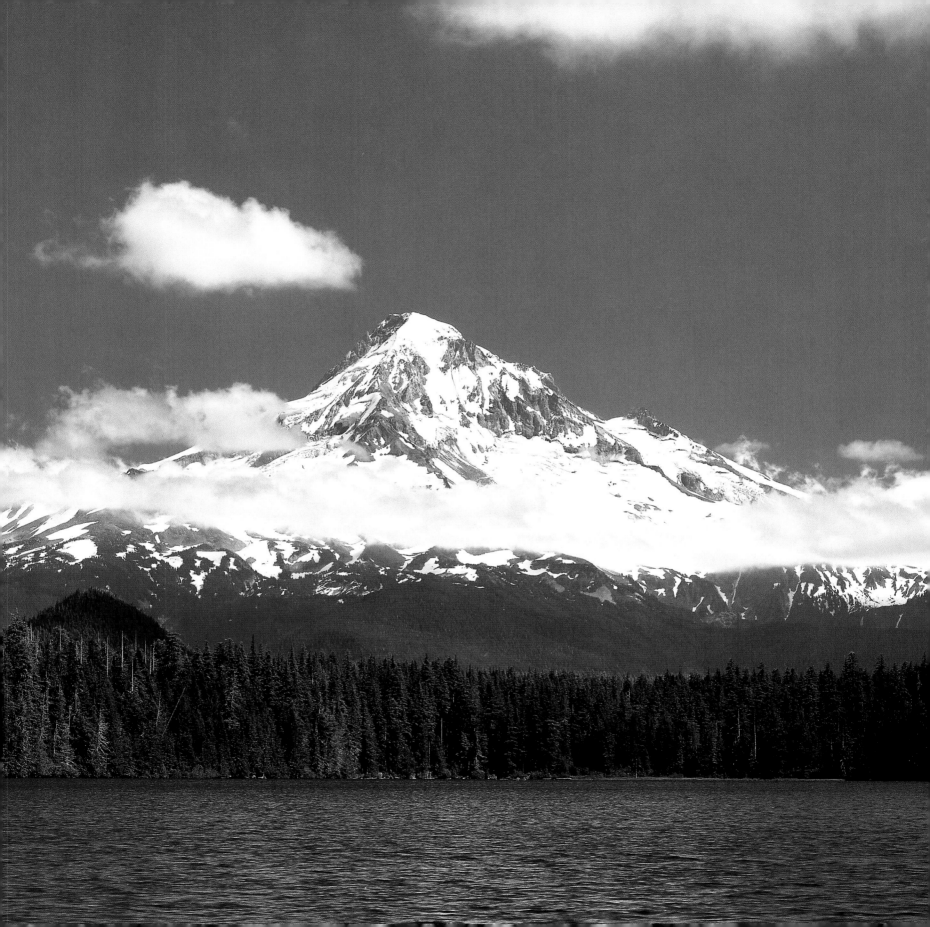

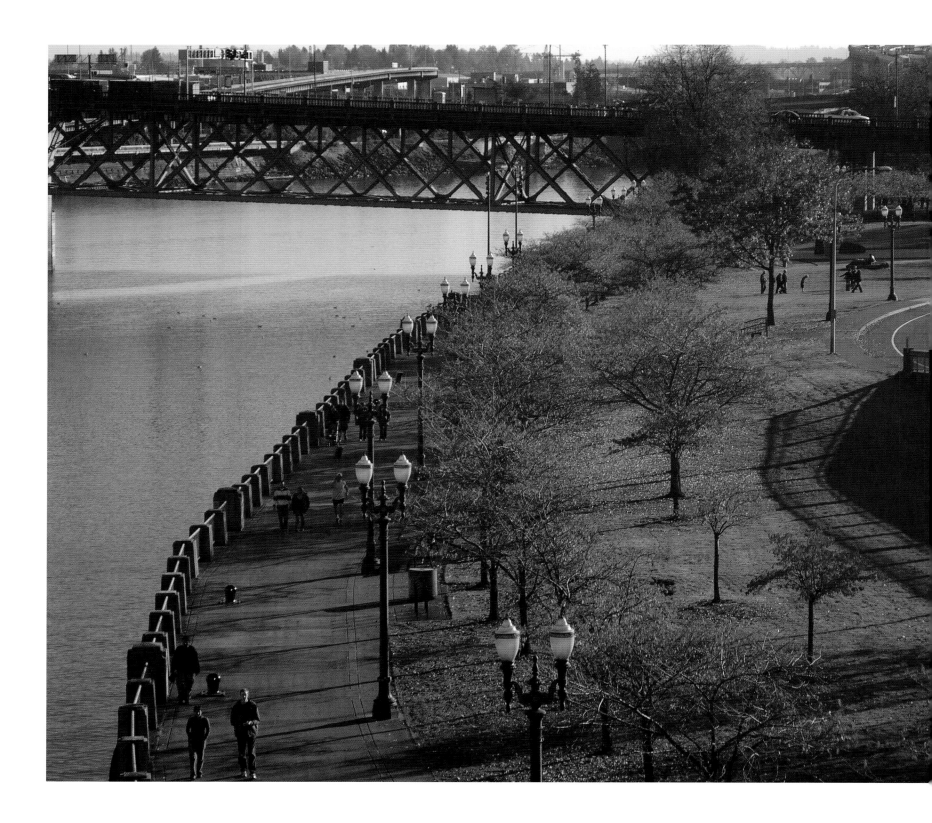

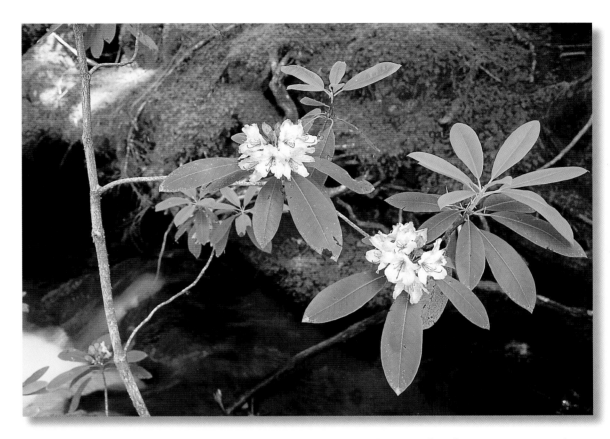

A rhododendron adds a touch of late spring color to the forest surrounding the Ramona Falls Trail. With blooms up to six inches across, several species of this well-known shrub are indigenous to the Coast and Cascade ranges.

In the fall, Portland's Tom McCall Waterfront Park is one of many whose trees explode with oranges, yellows, and reds. This park is located downtown on the west bank of the Willamette River and hosts many popular events, including the Waterfront Blues Festival, Oregon Brewers Festival, and many Rose Festival activities.

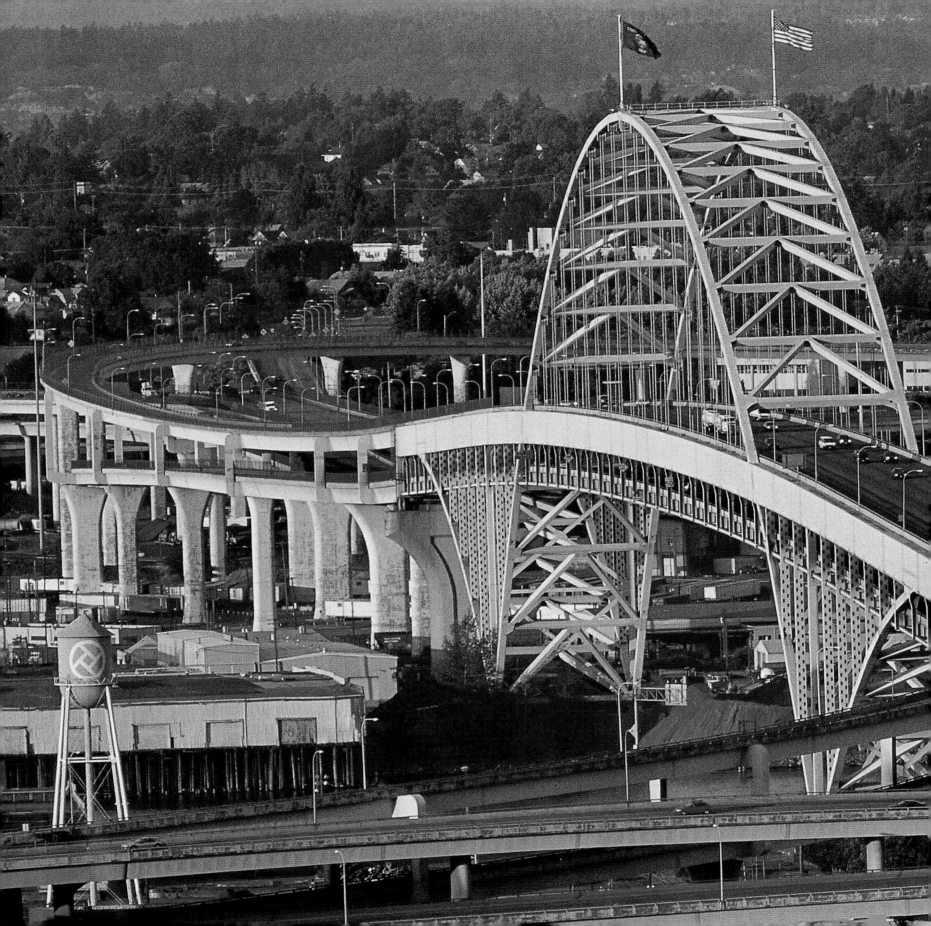

The Fremont Bridge in Portland comprises two decks that carry vehicular traffic over the Willamette River. In 1994, a pair of endangered peregrine falcons built a nest on the bridge. Thanks to the conservation efforts of hundreds of Portland's citizens, they have remained there, fledging new youngsters each year.

21

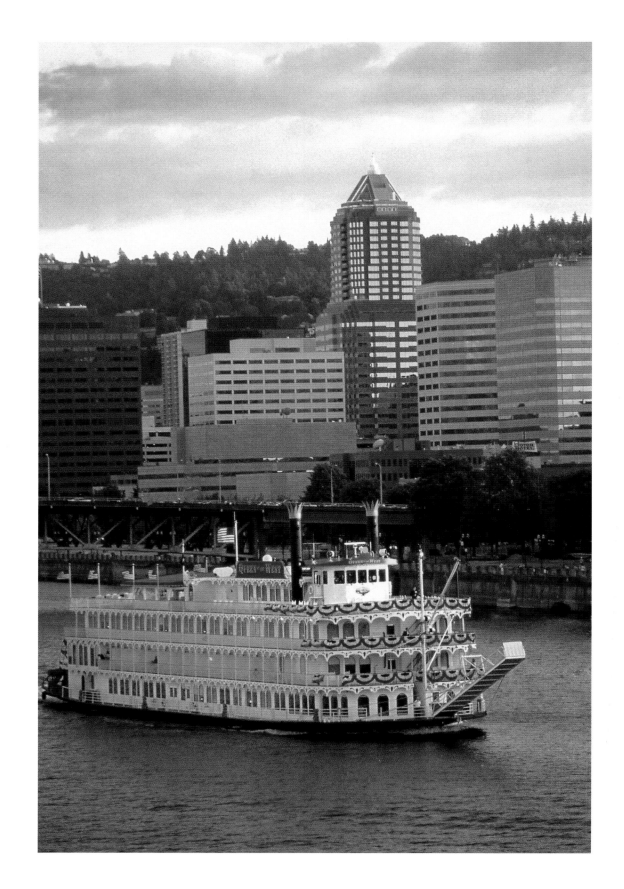

Portland's position on the Willamette River makes it a natural port for local and international vessels, from charter boats and freighters to pleasure yachts and kayaks.

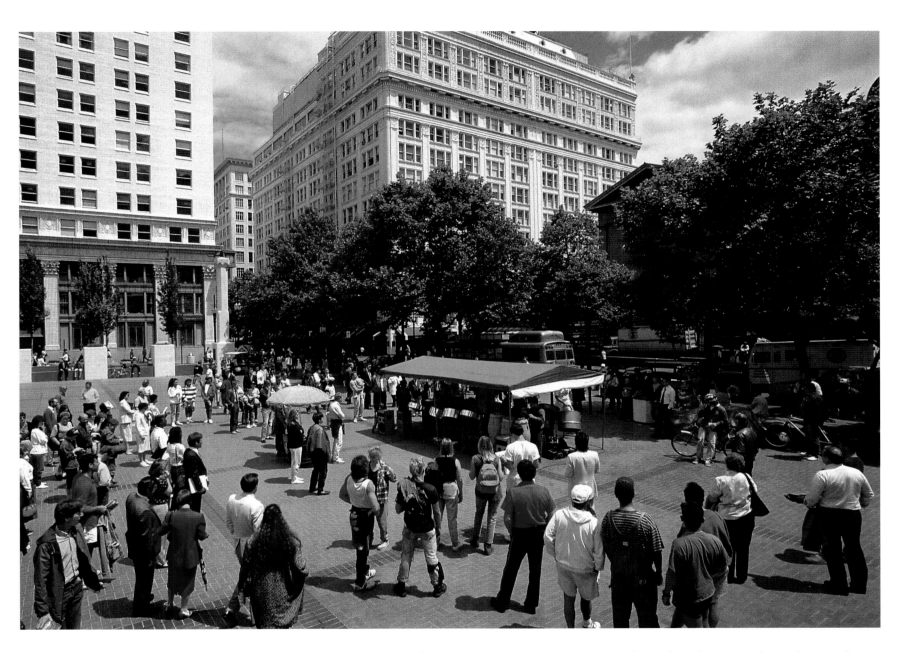

Pioneer Courthouse Square was the site of a school, a hotel, and a parking lot before thousands of Portland residents donated funds in the 1970s to create a public space. The downtown square is a natural gathering place, and concerts in the amphitheater attract large summer crowds.

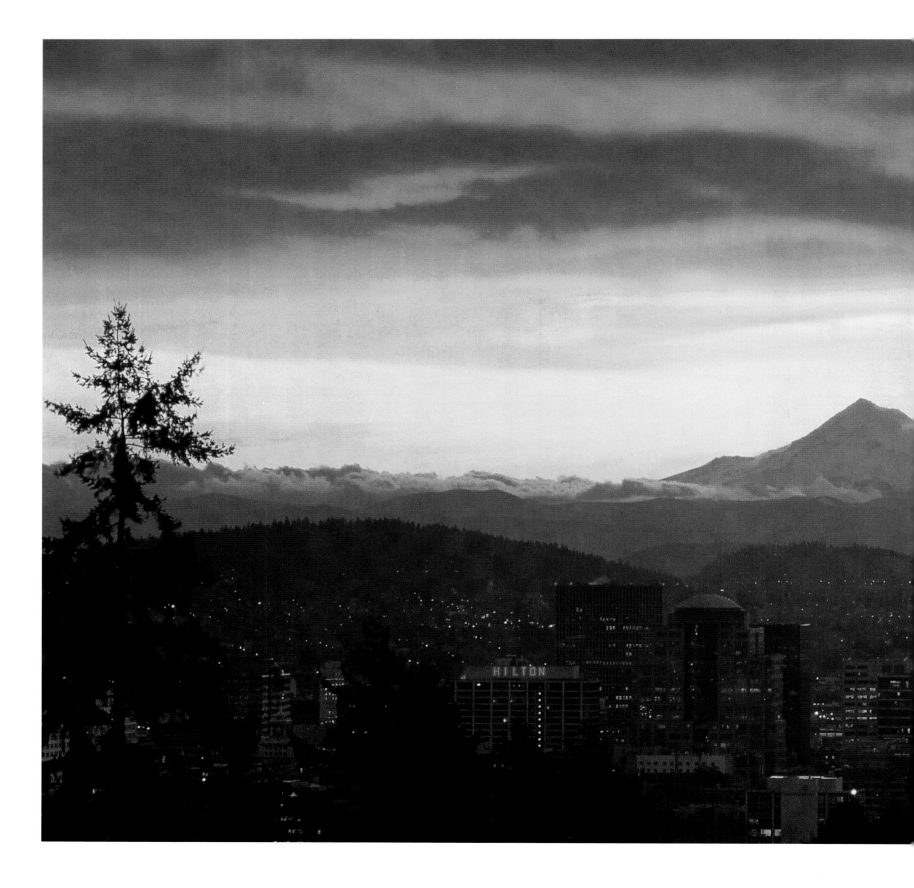

There is no shortage of interesting trivia about Portland. The city offers the world's largest bookstore and hosts the largest children's parade. To top it off, more Asian elephants are born at the zoo here than in any other North American city.

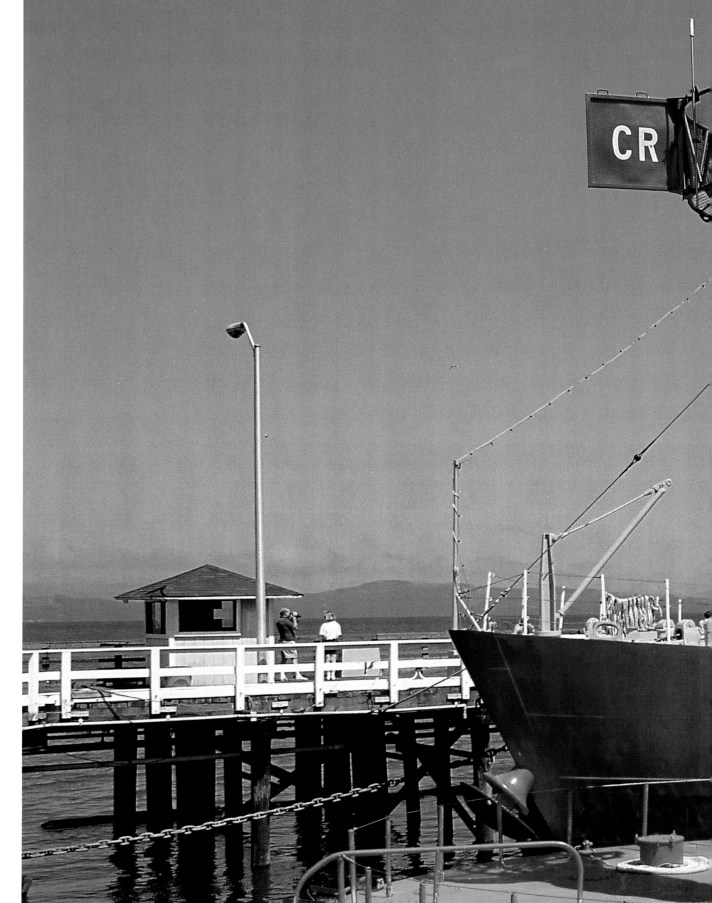

This decommissioned Coast Guard vessel and the buoy in the foreground are on display at Astoria's Columbia River Maritime Museum. Located at the mouth of the Columbia River, the museum offers a detailed look at the history of trade, recreation, wrecks, and rescues in the Pacific Northwest.

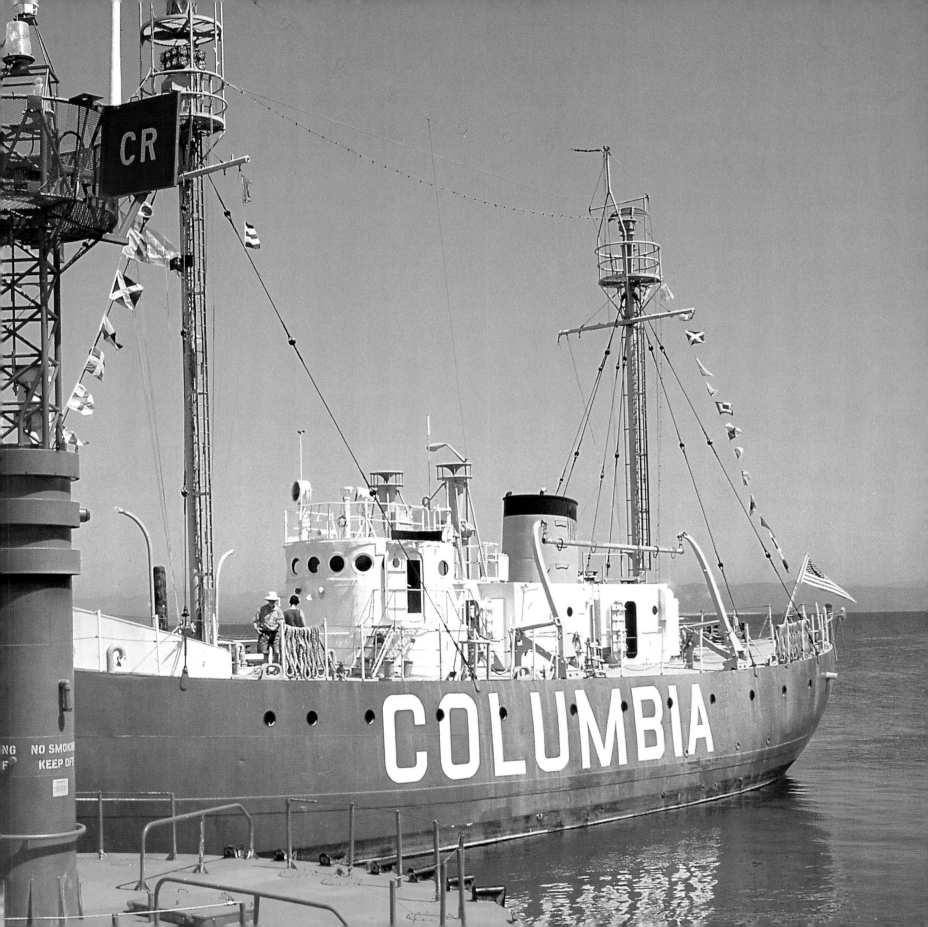

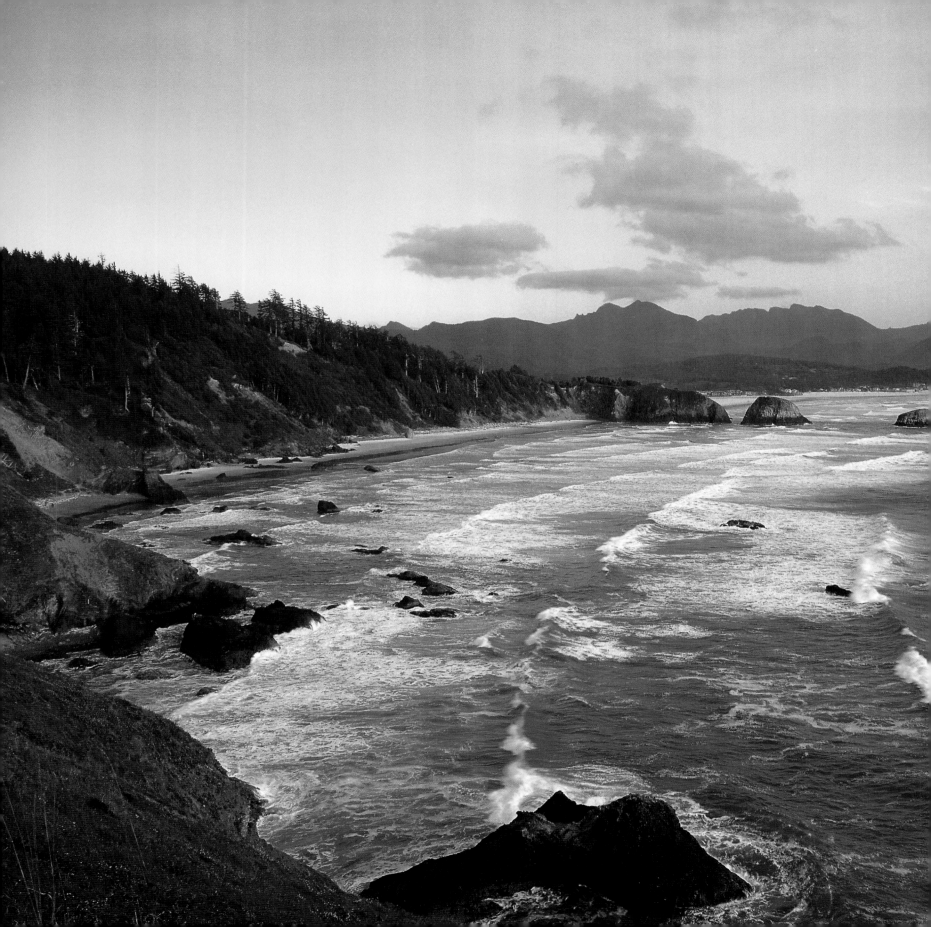

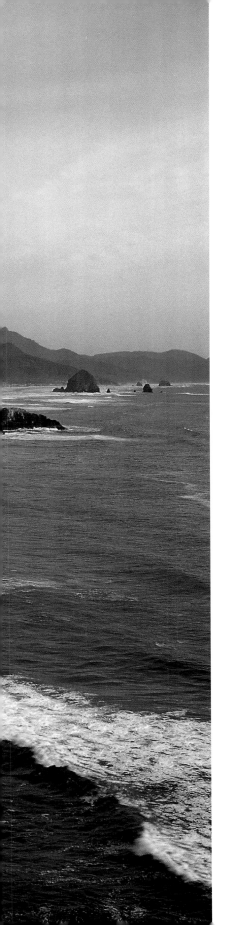

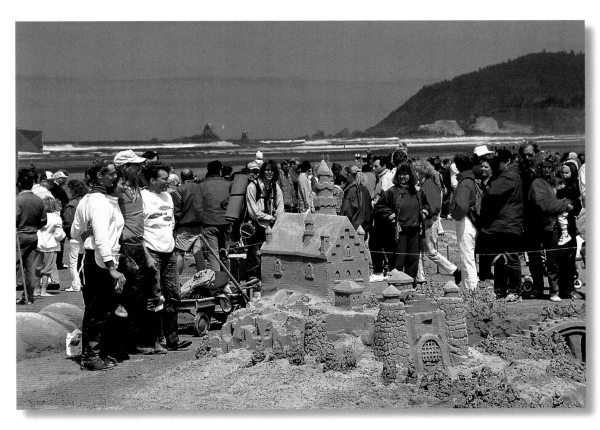

More than 1,000 shovel-wielding, bucket-toting, artistically inclined sand-castle builders descend on Cannon Beach each May. They begin work at dawn, judging starts at noon, and by the next day all traces of the event have been washed away by the tide.

The wreck of the *Shark* at the mouth of the Columbia River in 1846 deposited a cannon on the shore, giving Cannon Beach its name. Today, the beach is a popular haven for artists, writers, and holiday crowds.

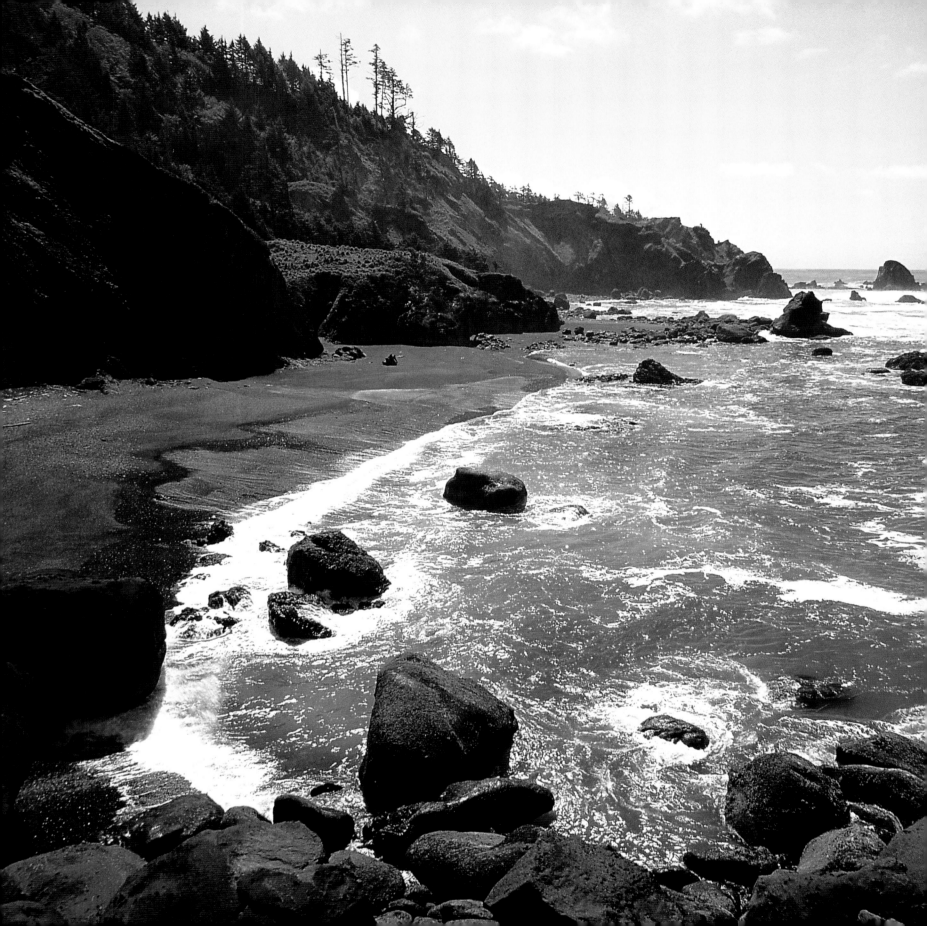

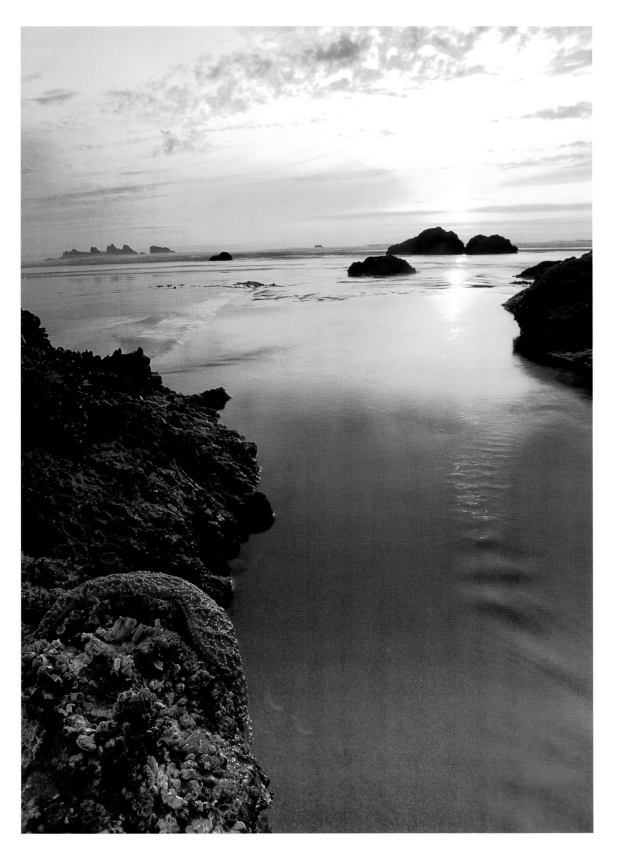

The sea stacks in Bandon are some of the most interesting on the coast. Their names—including Elephant, Cat and Kittens, and Face rocks—attest to their unique shapes.

OPPOSITE—
The intertidal zone, covered by water only part of the time, is rich in life. It supports starfish, crabs, and a myriad of other small creatures.

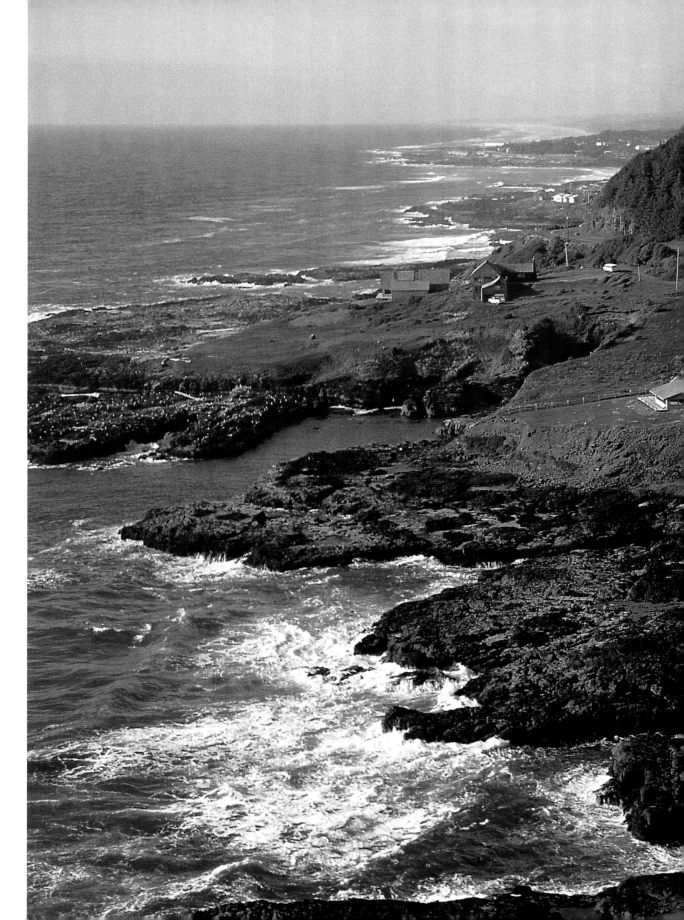

Although houses dot the cliffs above Oregon's coastline, the beaches are public property from the beginning of the water to 16 vertical feet above the low tide mark.

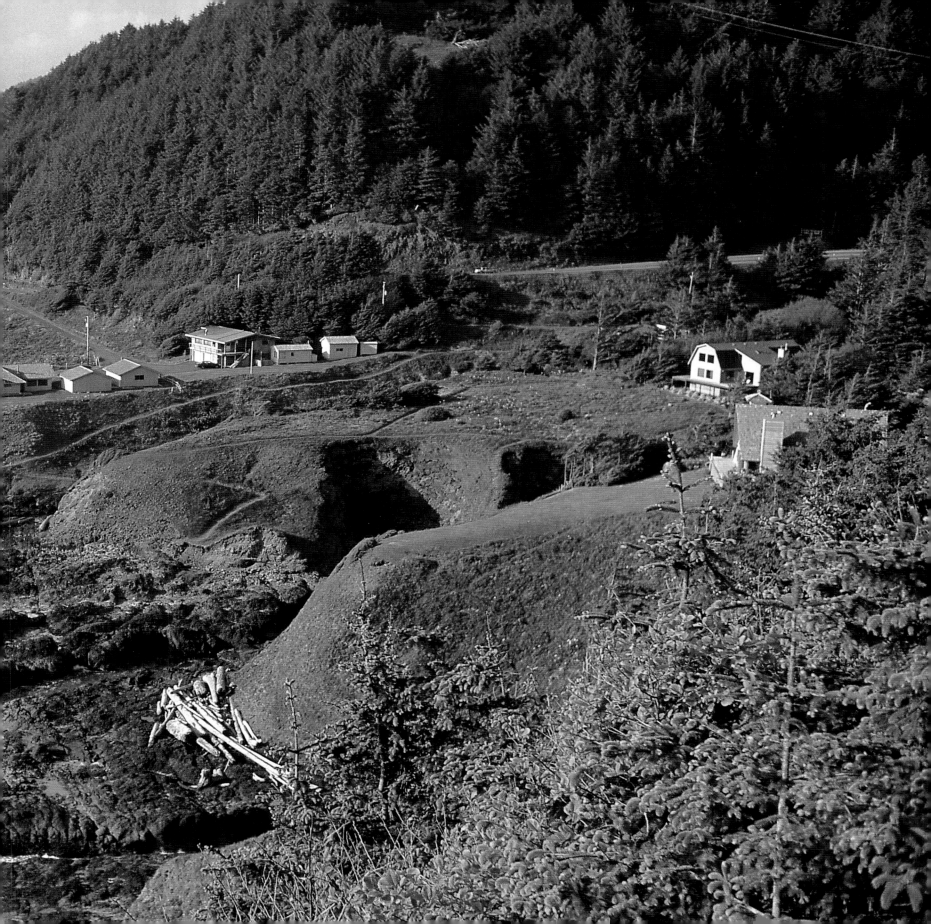

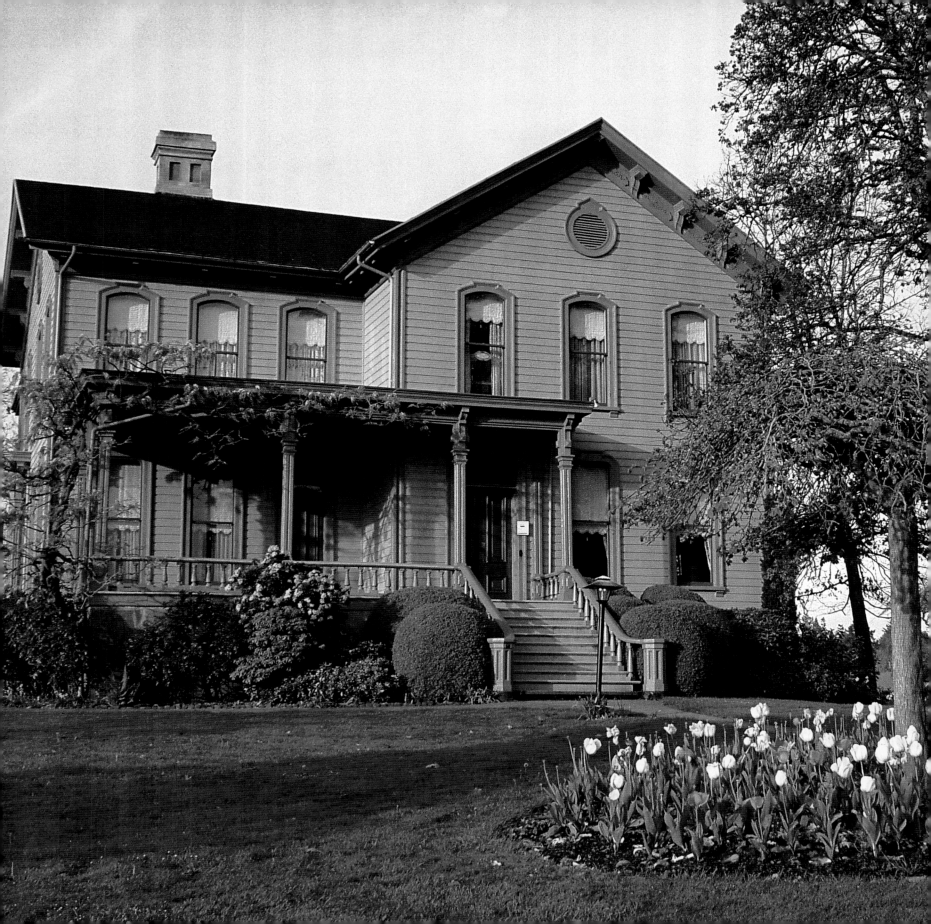

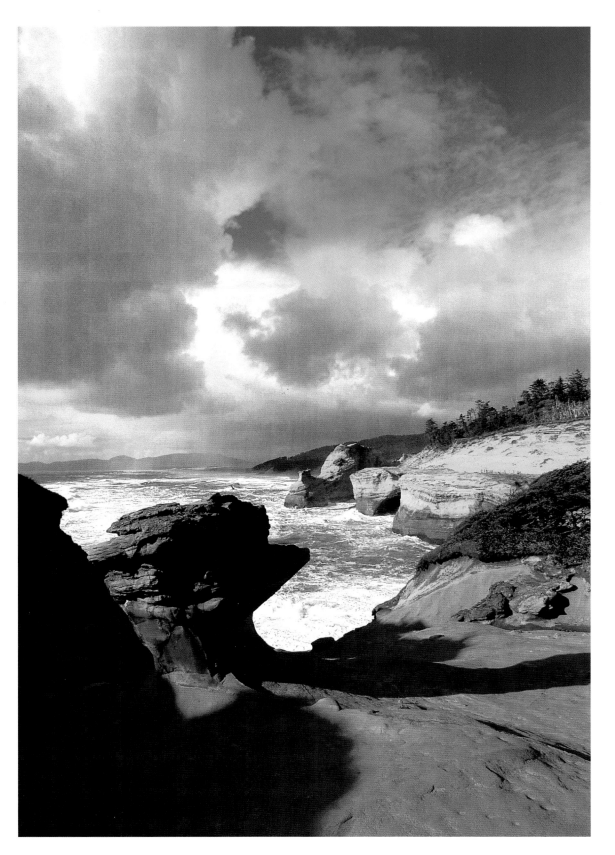

Crashing surf has carved the cliffs of Cape Kiwanda into erratic shapes. Just off shore, the 327-foot-high Haystack Rock is one of two sea stacks that bear this name. The other can be seen off the shore of Cannon Beach.

OPPOSITE—
Bush House was built in 1877 by banker and newspaper publisher Asahel Bush, one of Salem's more notorious and outspoken pioneers. The house is now a museum featuring many of the original furnishings.

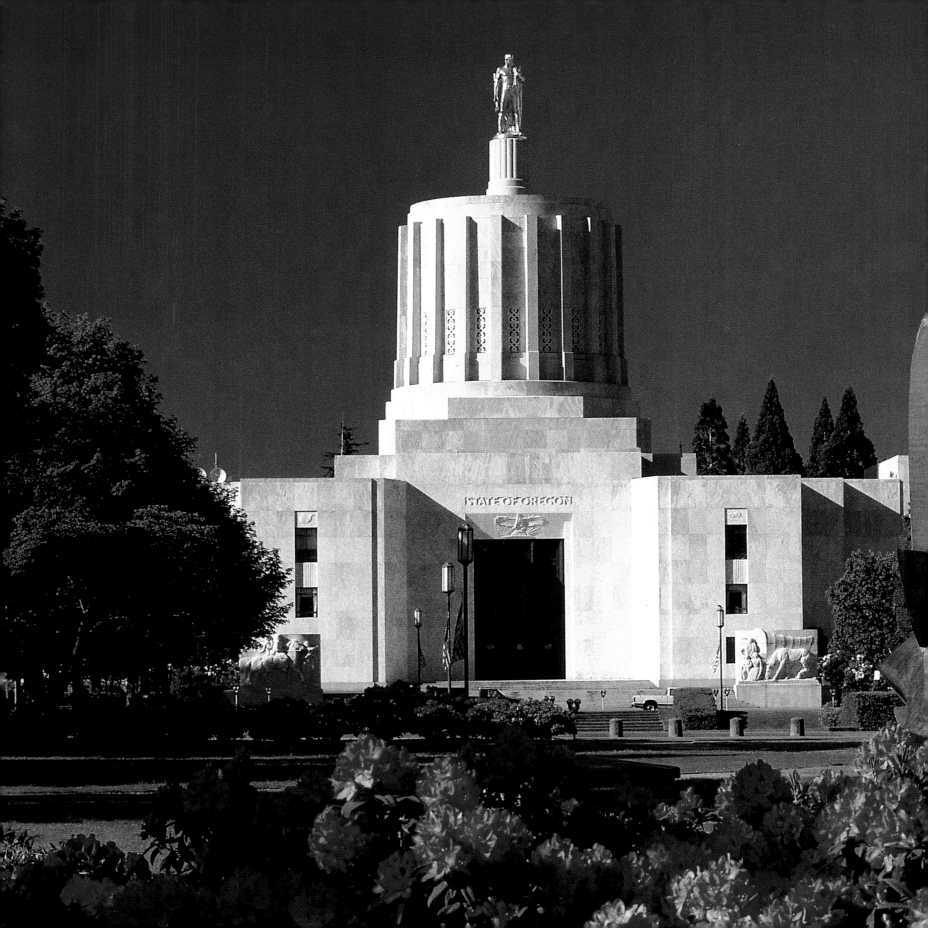

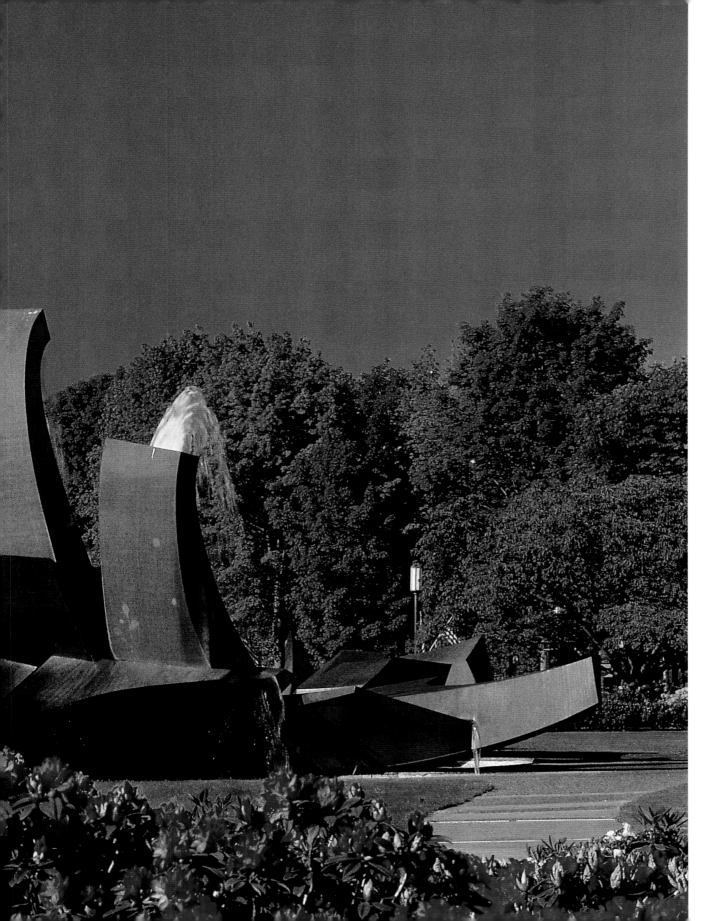

Founded in 1840, Salem became the capital of the territory in 1851. It became capital of the state when Oregon joined the Union in 1859.

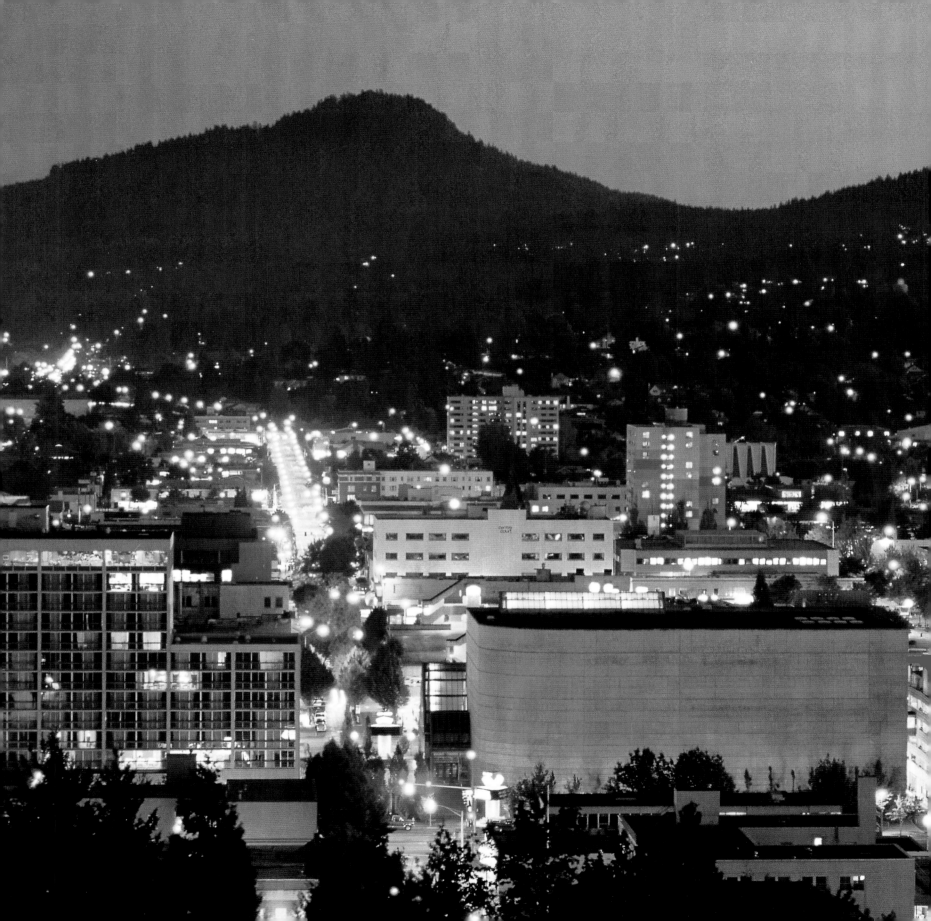

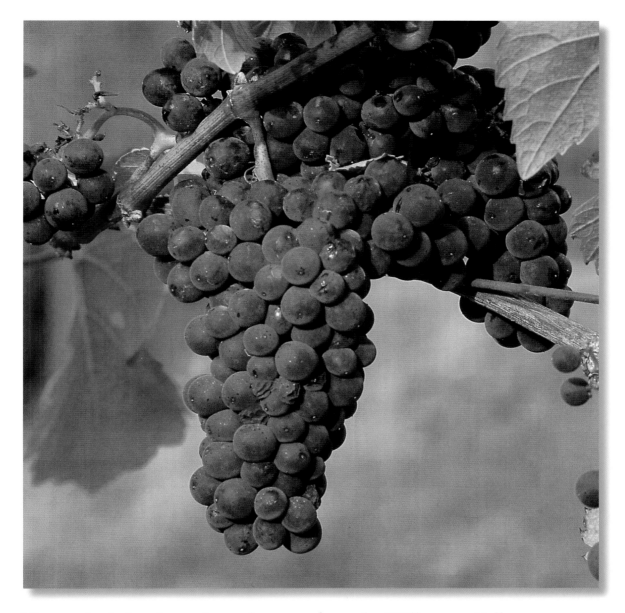

Vineyards thrive throughout the state, from the Willamette Valley
and Yamhill Country to Ecola Hills and the Rogue Valley.

Eugene is known for its array of festivals and cultural
events, from the Saturday Market to the Bach Festival.

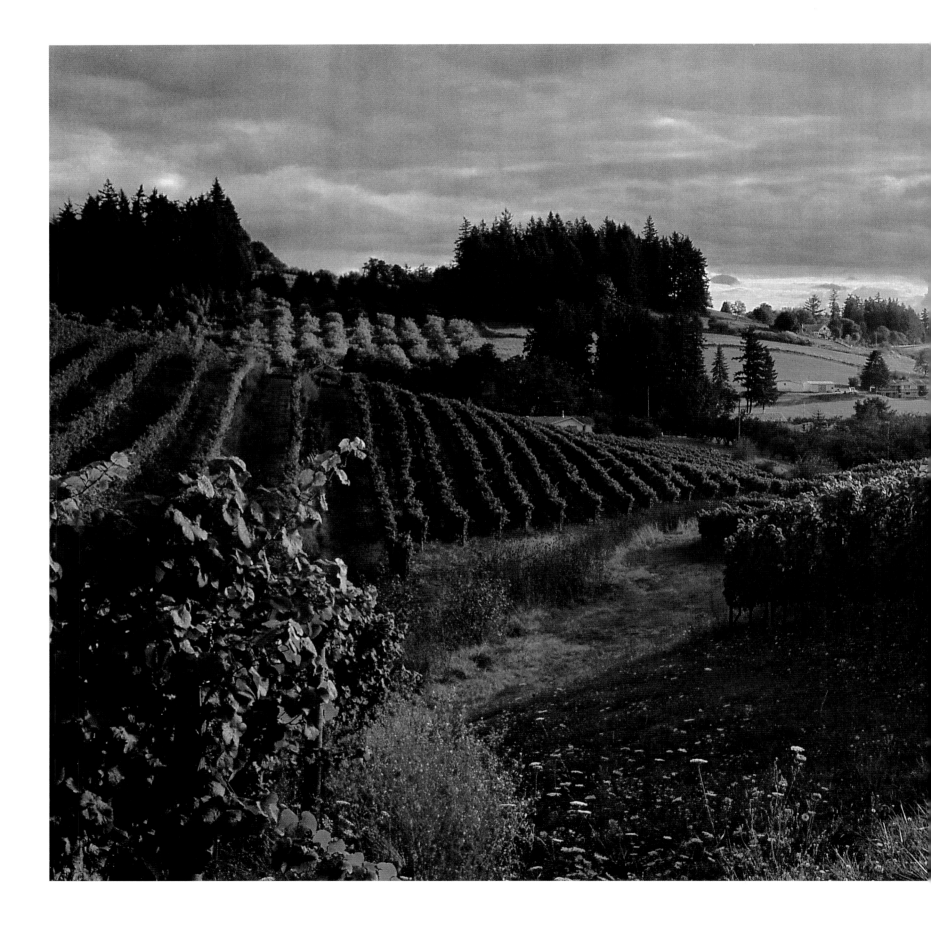

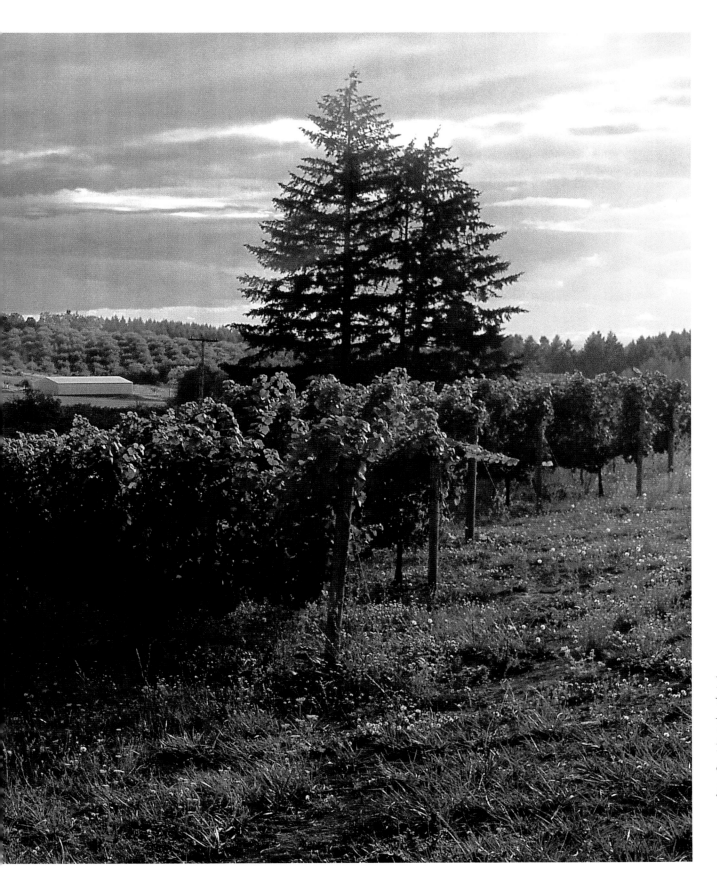

In the 1980s, the Willamette Valley became one of the first regions to be developed for grape growing.

Built in 1871 as one
of nine beacons on
the coast, Yaquina Bay
Lighthouse has now
been restored, and is
open to the public.
Reputedly, there is a
resident ghost.

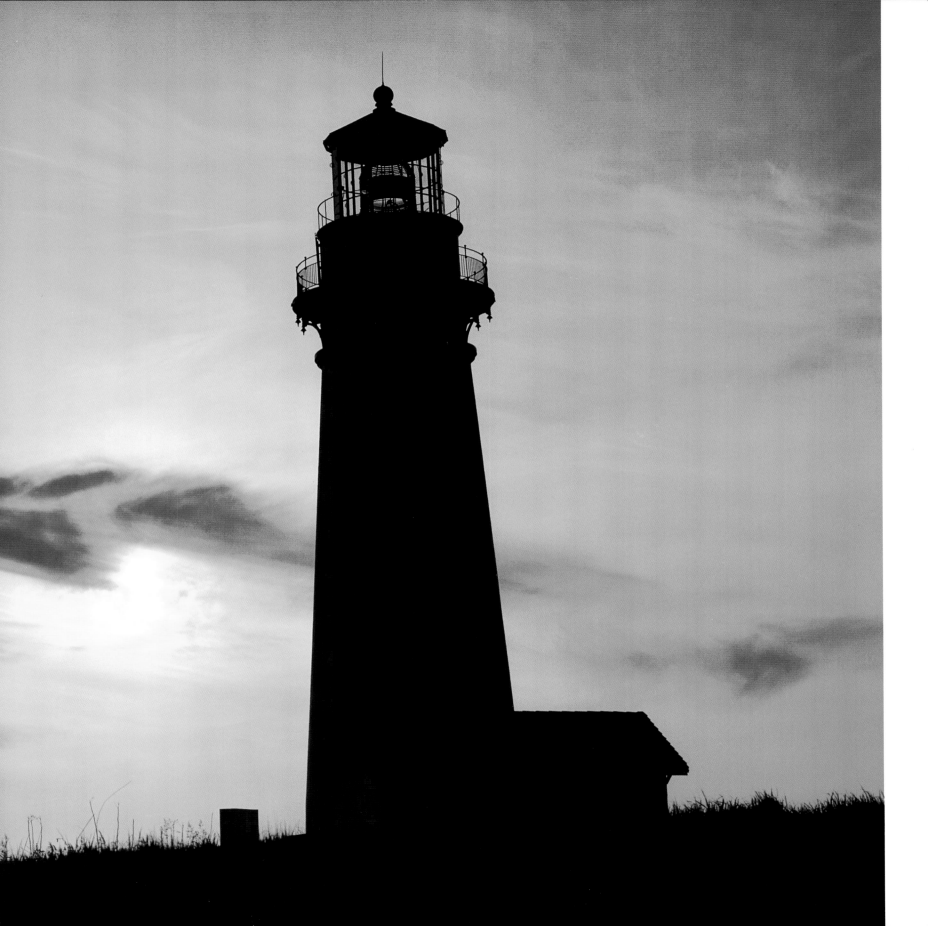

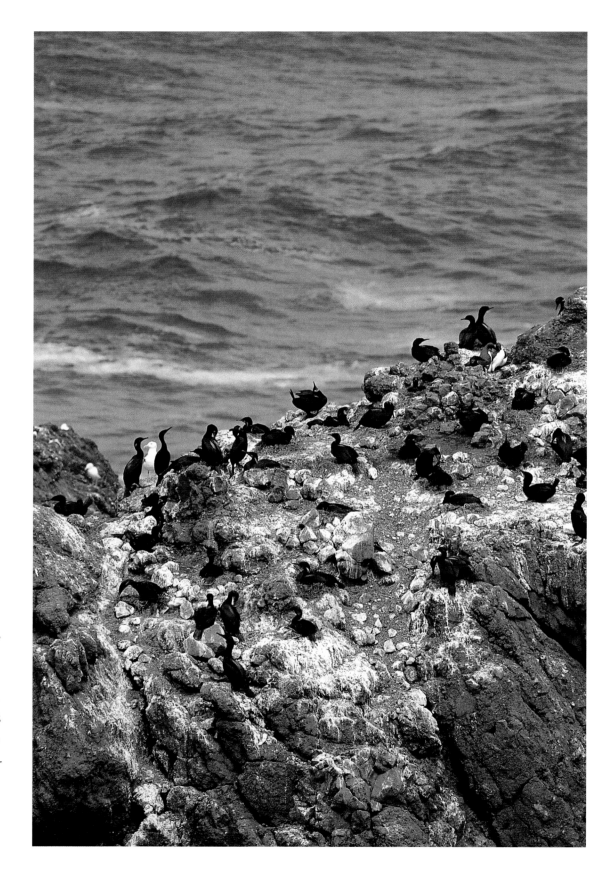

Tufted puffins, cormorants, and murres take refuge on Colony Rock, a steep outcropping off Yaquina Head. Access to many of Oregon's offshore islands is prohibited, to help protect the nesting sites of these birds.

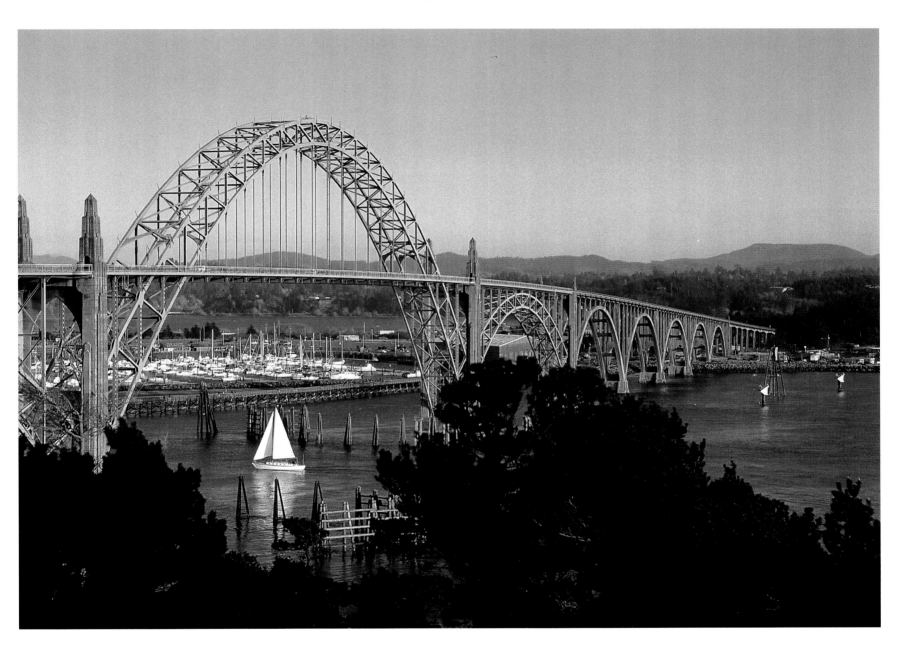

The Yaquina Bay Bridge in Newport is the most recognizable bridge designed by Conde McCullough. A bridge engineer, McCullough designed many of Oregon's coastal bridges along US Route 101.

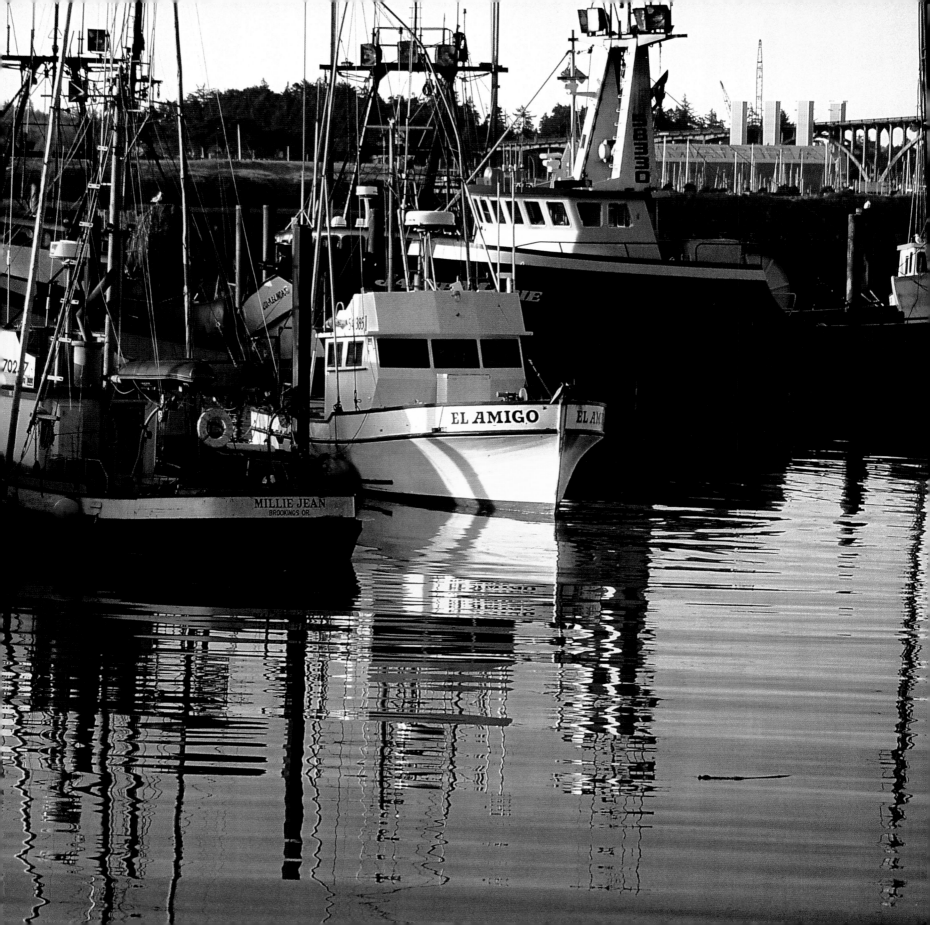

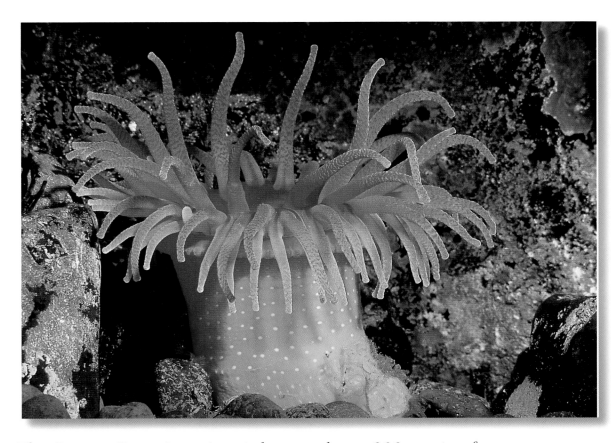

The Oregon Coast Aquarium is host to almost 200 species, from Dungeness crabs to leopard sharks and 21 kinds of sea stars.

Newport was founded upon the popularity of the oyster—and its abundance in Yaquina Bay. Fishing continues to be a central part of the economy, and up to 600 vessels can moor in the city's harbor.

Oregon Dunes National Recreation Area encompasses some of the world's largest oceanside sand dunes. The 32,000-acre area is frequented by dune-buggy drivers, hikers, and horseback riders.

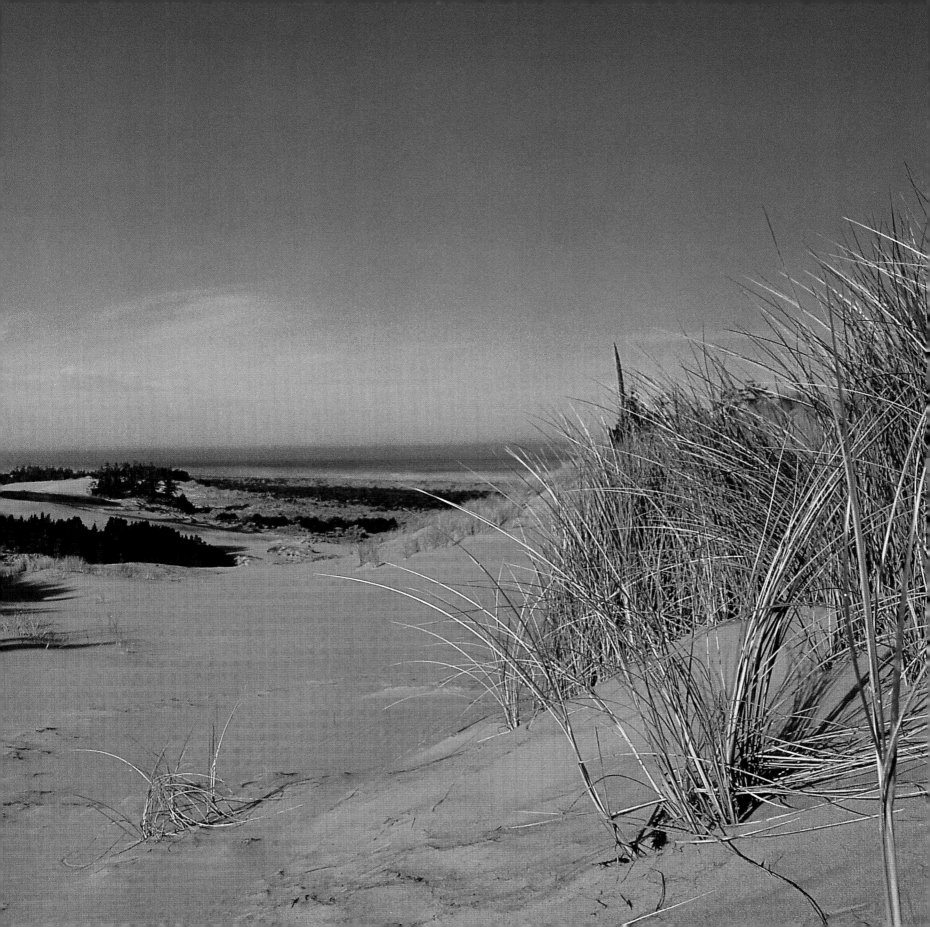

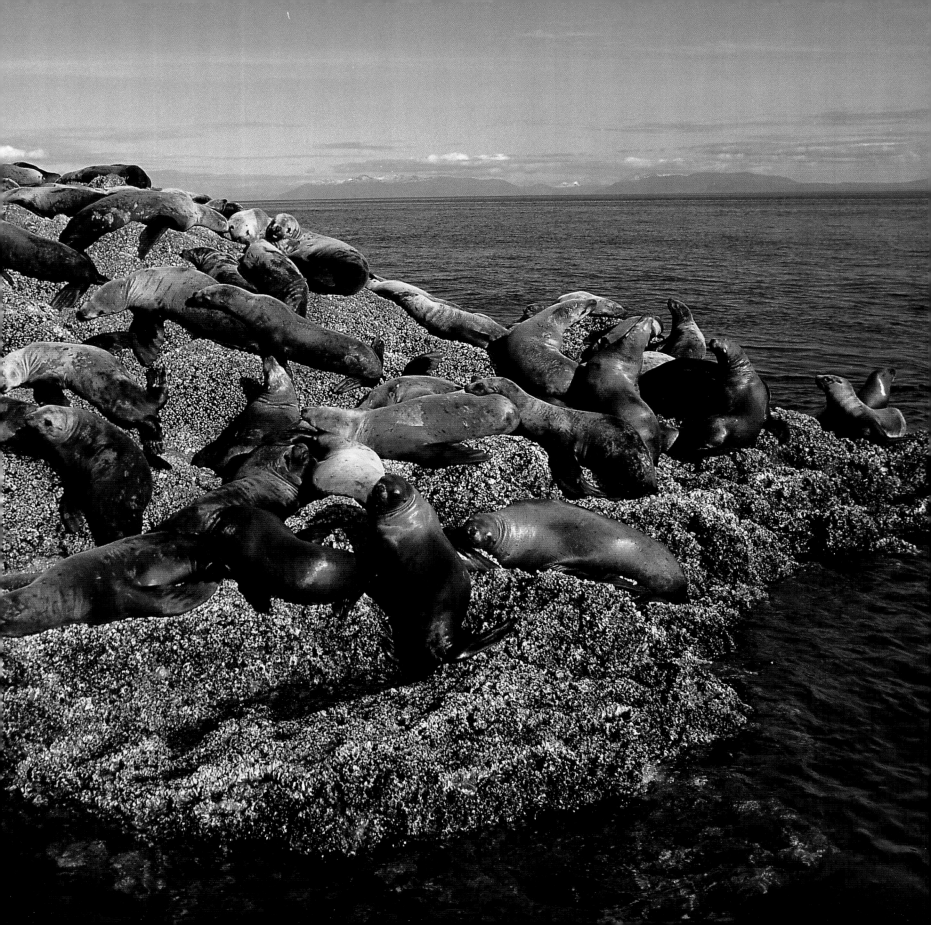

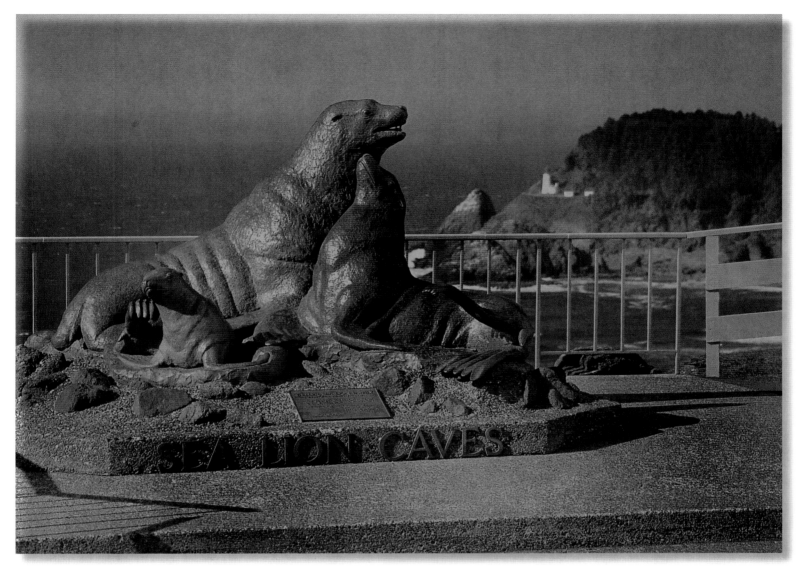

Most sea lions breed on islands. This monument marks the Sea Lion Caves, the largest sea caves in North America and home to the only Steller sea lion herd known to breed on the mainland.

Groups of Steller and California sea lions hunting fish and basking on the rocks are a common sight along the coast. In the winter, thousands of these giant creatures may gather near herring schools.

The state offers unlimited fishing opportunities, from surf fishing along the coast to angling in the lakes of the dunes. Salmon thrive in the rivers, trout populate the inland lakes, and the occasional sturgeon is glimpsed in the Columbia River.

OPPOSITE—
Oregon's southern coast is less populated than the tourist-oriented north coast. Here, small towns lie along the quiet bays and fishing and logging industries coexist with the beauty of the long beaches and quiet islands.

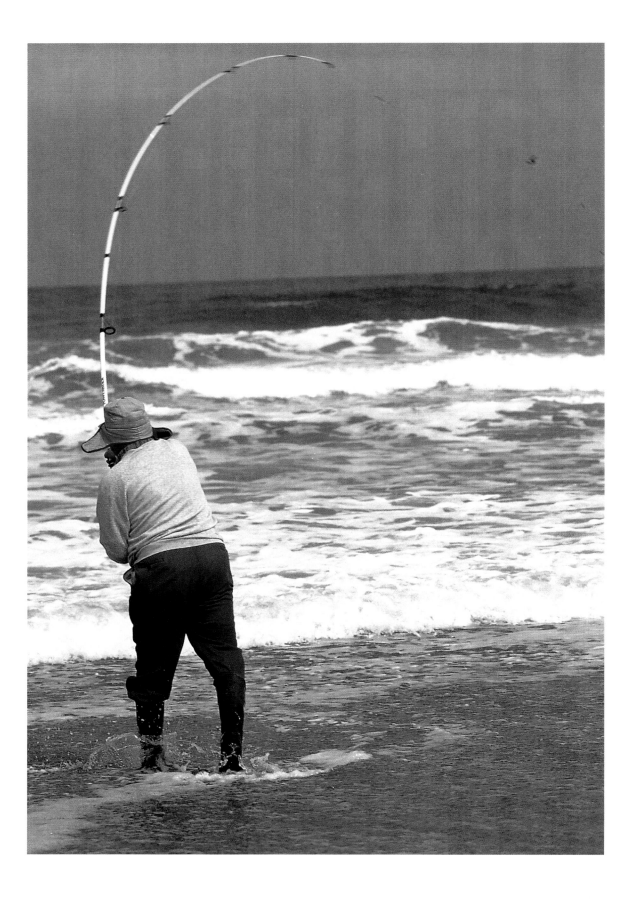

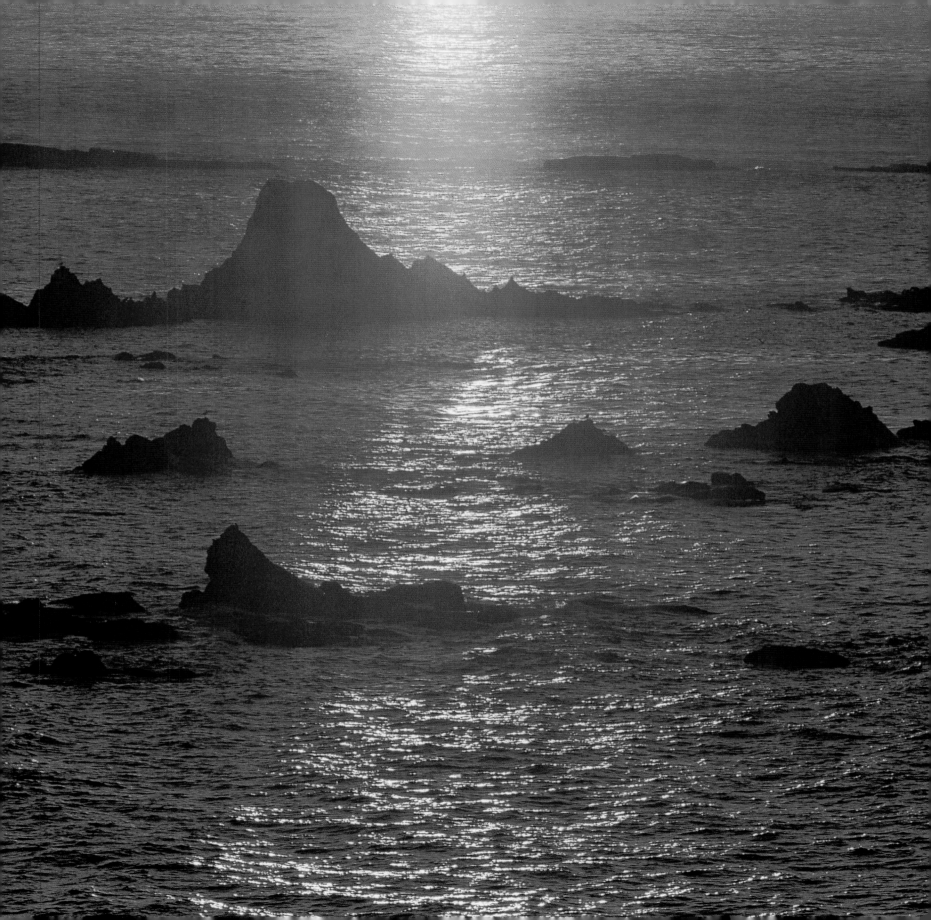

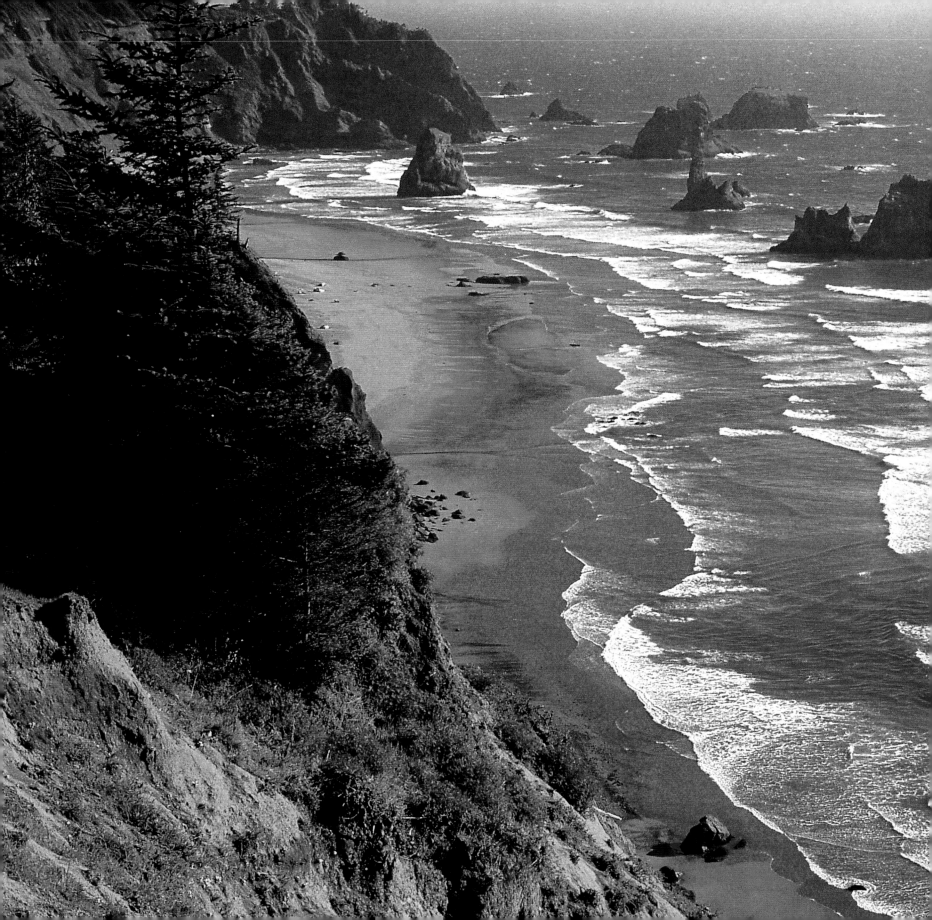

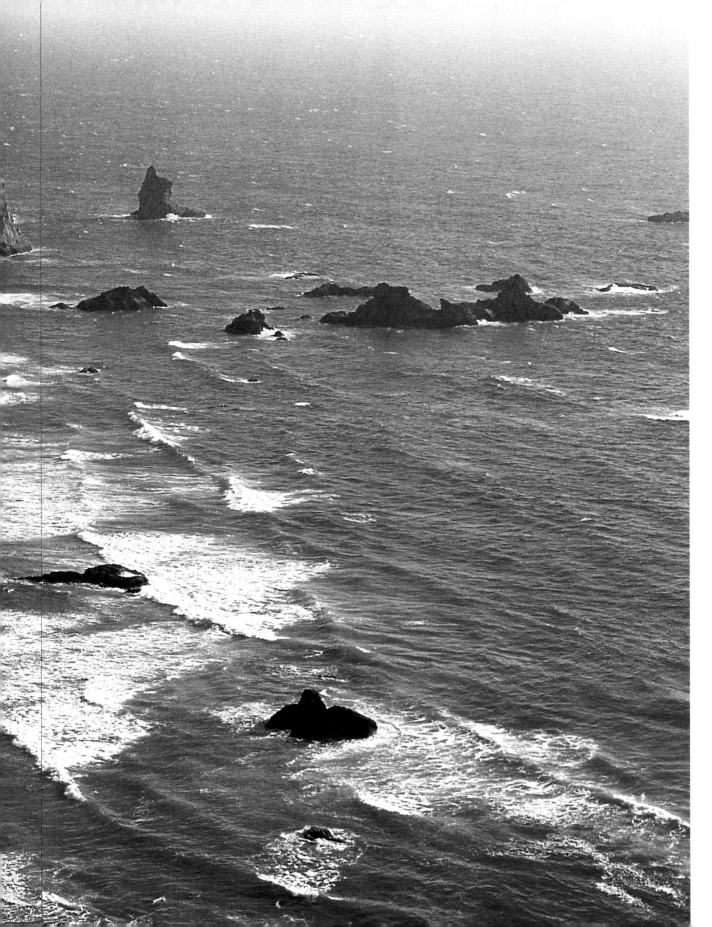

Samuel Boardman State Park hugs the coast for 11 miles, allowing spectacular vistas from numerous viewpoints along Highway 101.

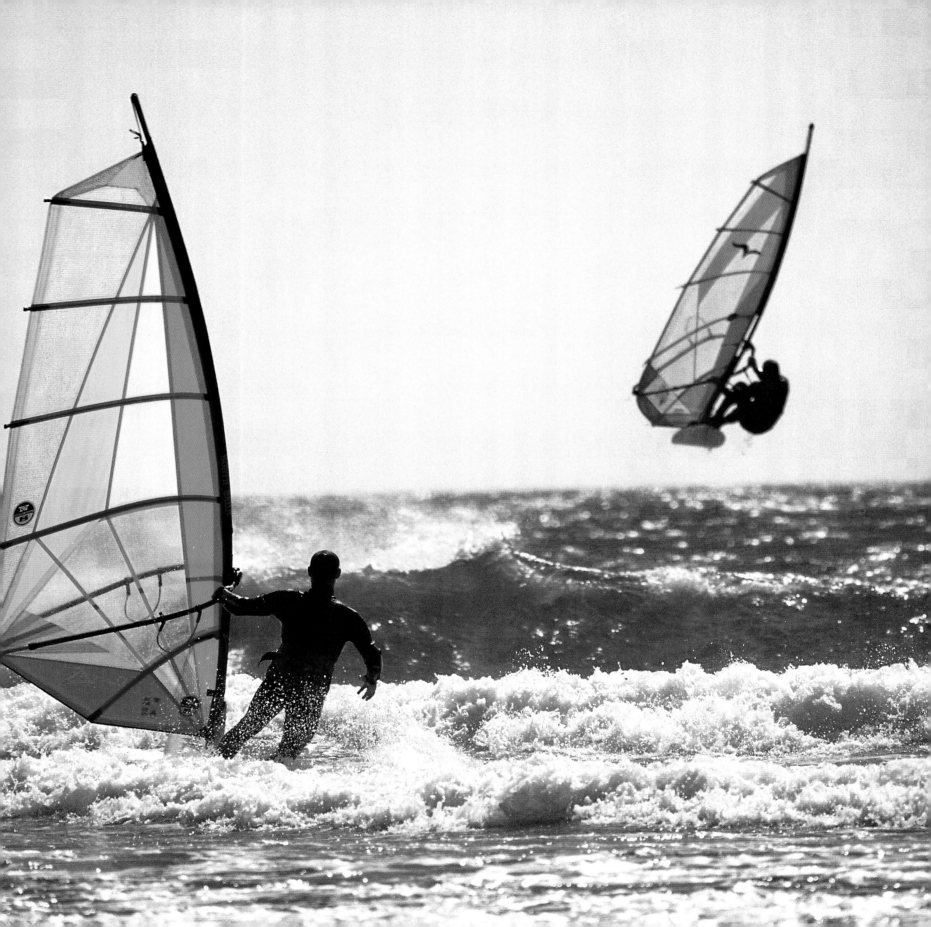

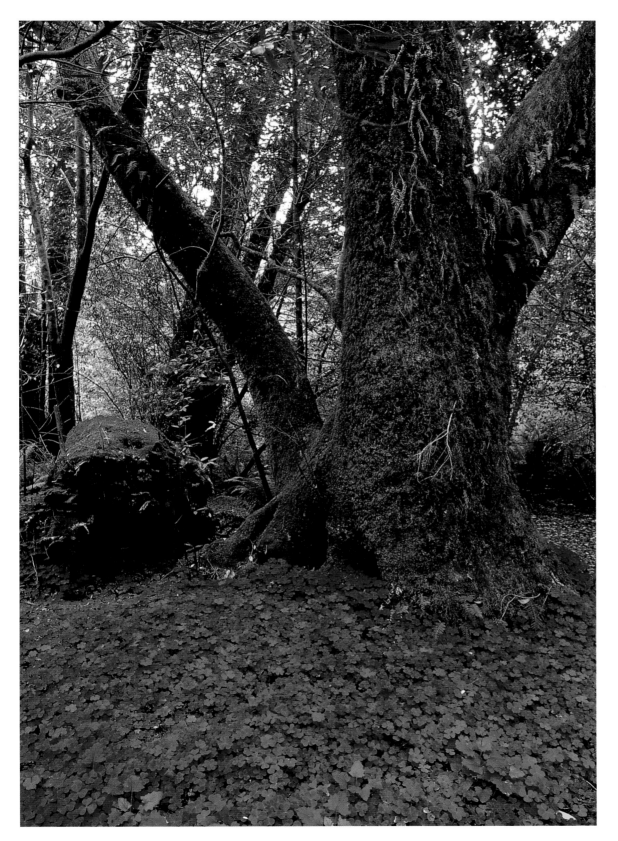

Loeb State Park preserves
old-growth myrtlewood—
the largest surviving
grove of it in Oregon.
Giant redwoods also grace
the park, some more
than 300 feet high.

OPPOSITE—
Wind surfers race the
waves at Pistol River State
Park. Though the Columbia
River Gorge is the best-
known windsurfing venue,
surfers can find a suit-
able breeze at many places
throughout the state.

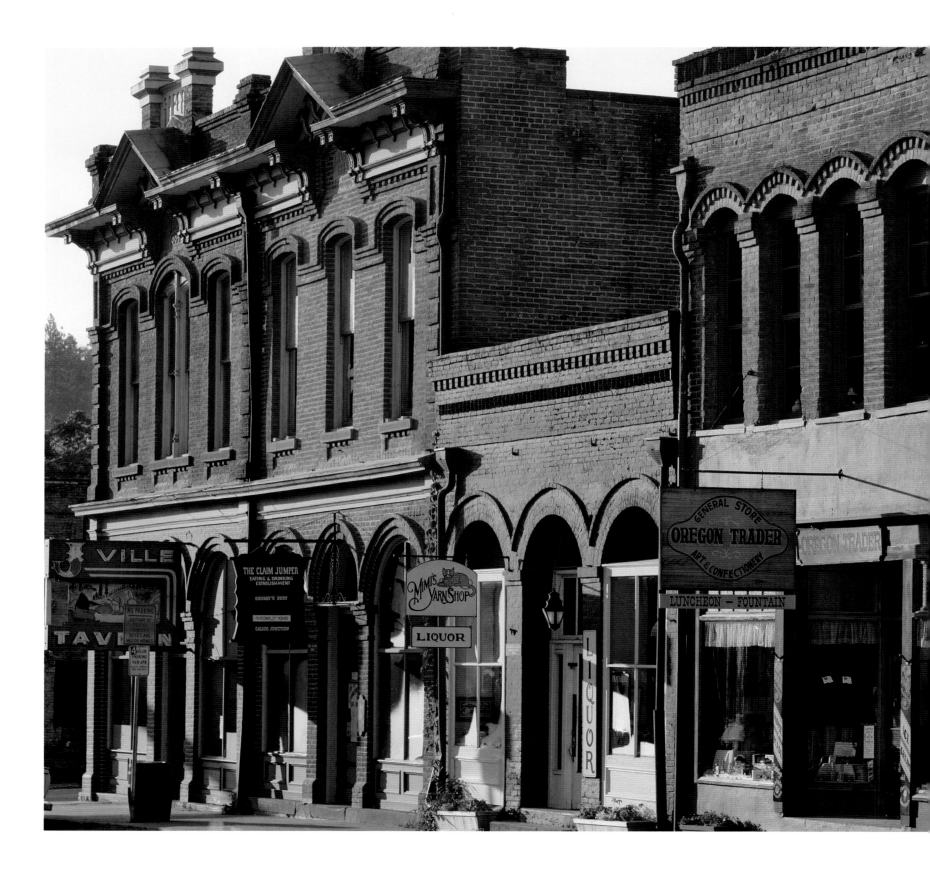

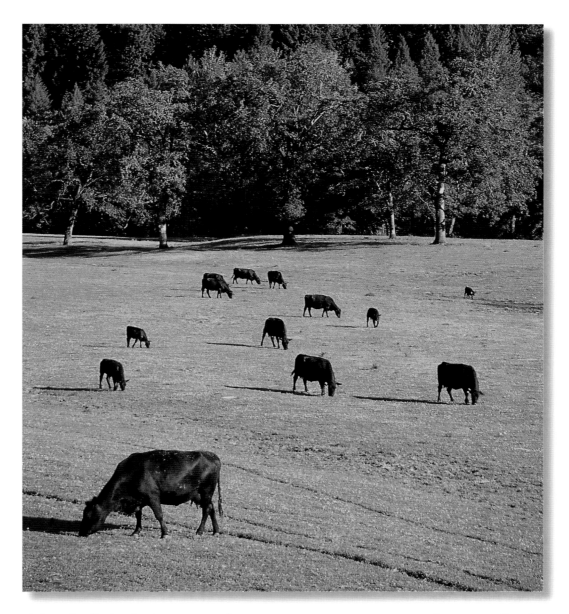

A herd of Black Angus cattle create a picturesque rural scene. Cattle are the state's second-largest commodity, after greenhouses and nurseries. Livestock is particularly important in the Willamette Valley and the southeast.

Visitors to Jacksonville can step back to the gold rush days. Almost 100 buildings along California Street and throughout the town have been restored to their original 19th-century boomtown beginnings.

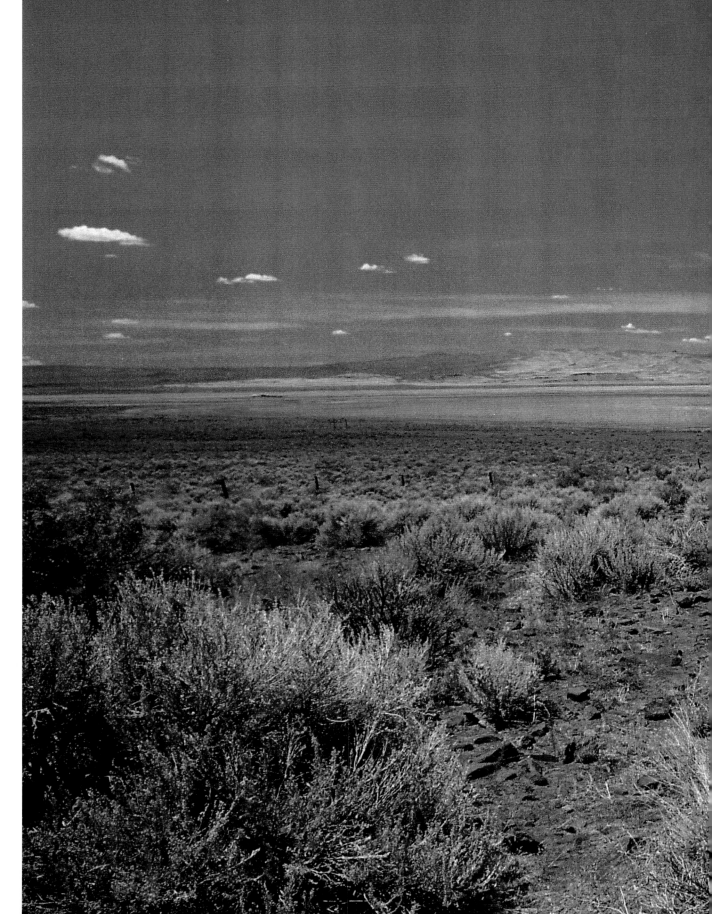

Hart Mountain Antelope Refuge was established in 1936 to protect the summer range of Oregon's pronghorn antelopes. The region is also home to bighorn sheep, deer, coyotes, and a wide array of bird species.

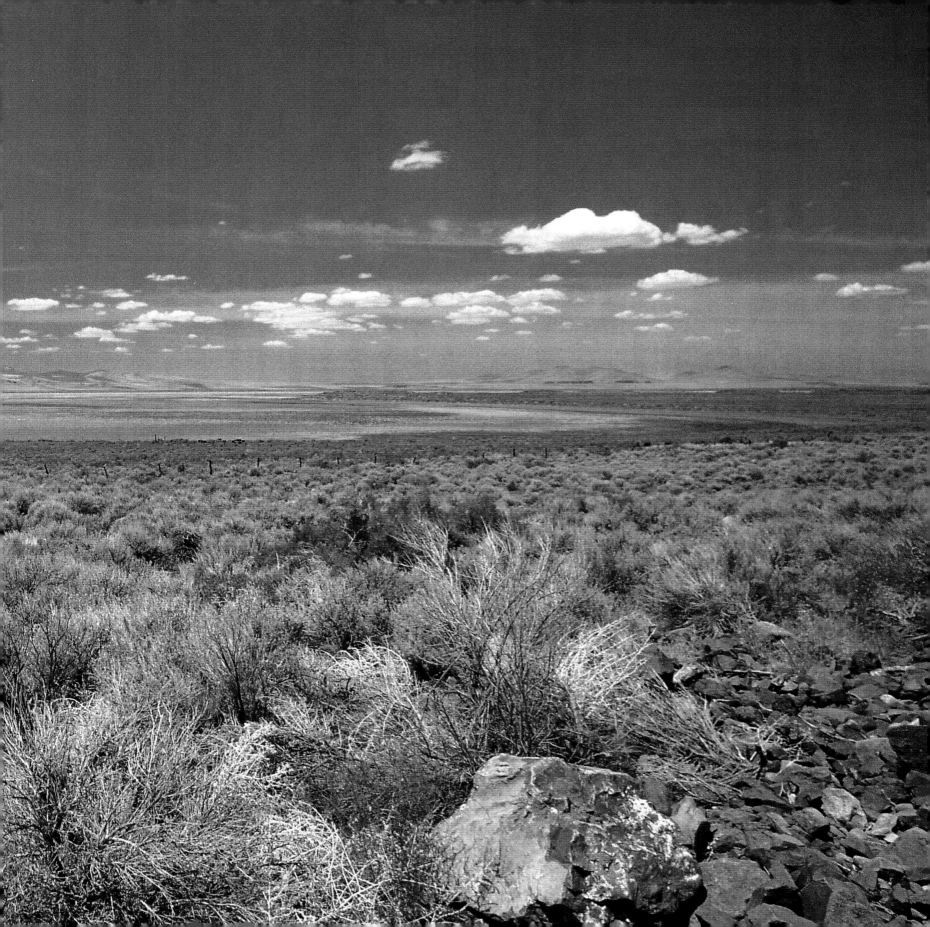

North America's only sur-
viving antelope species,
the pronghorn antelope
has steadily lost its range
to farmers and ranch-
ers. Though its numbers
were severely threatened
in the 1900s, the popula-
tion has now rebounded.

OPPOSITE—
The high desert region
of southeast Oregon suf-
fers frequent drought.
Only a few hardy plants
can survive in the dry,
windswept earth.

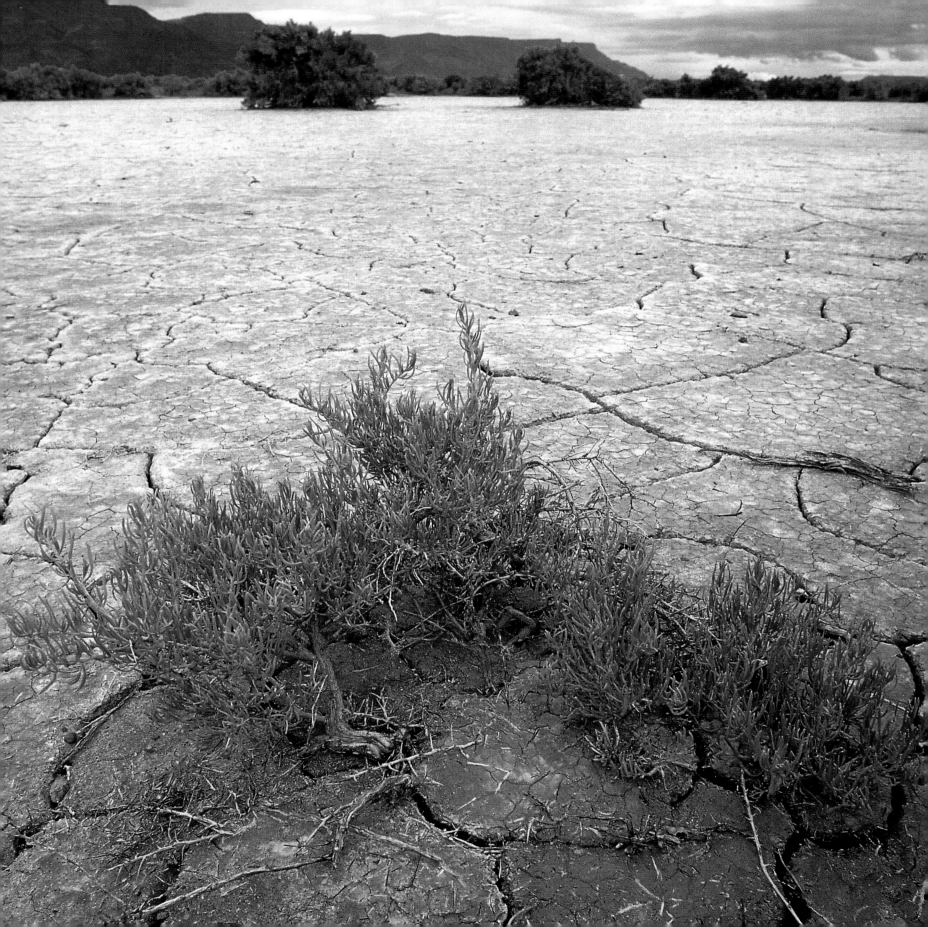

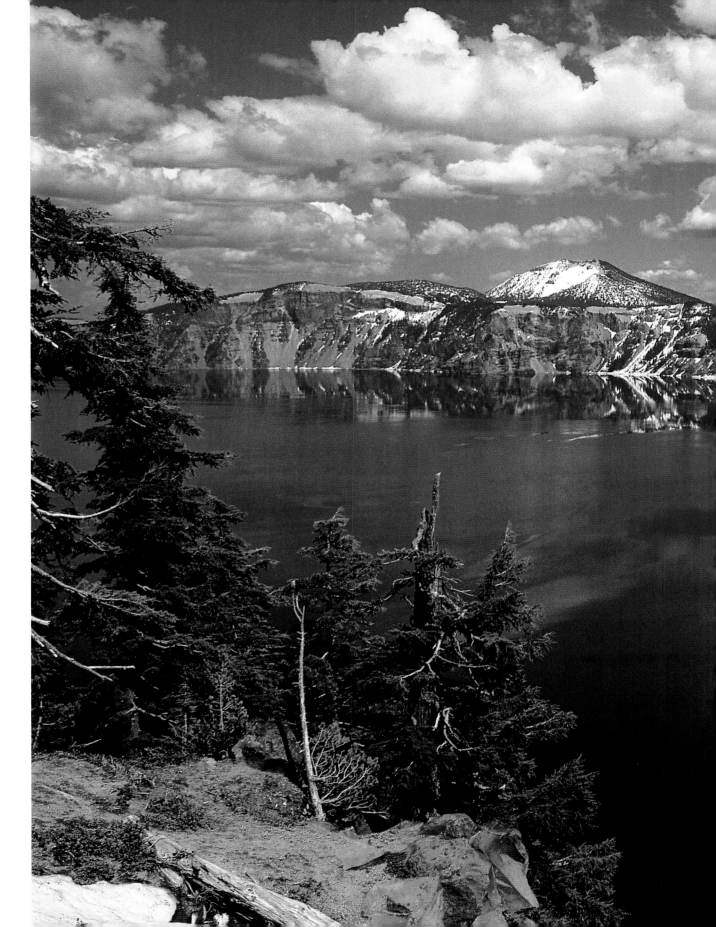

At 1,932 feet, Crater Lake is America's deepest lake. It is also one of the country's oldest national parks, established in 1902.

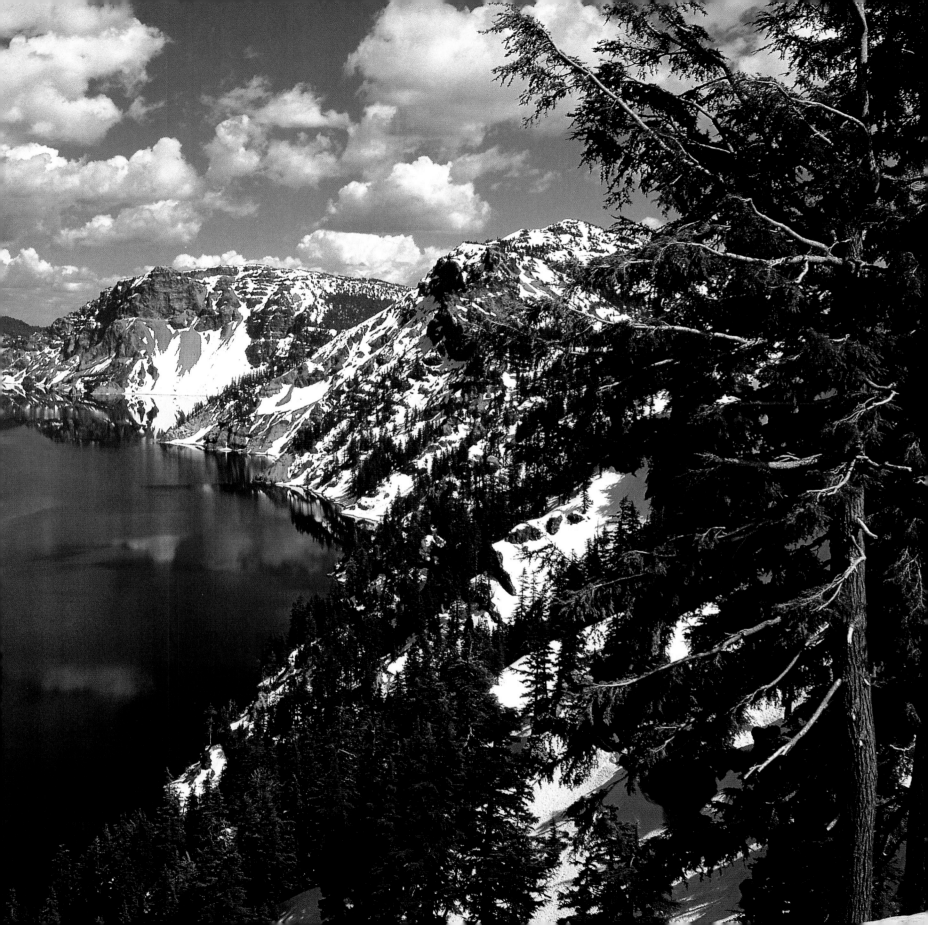

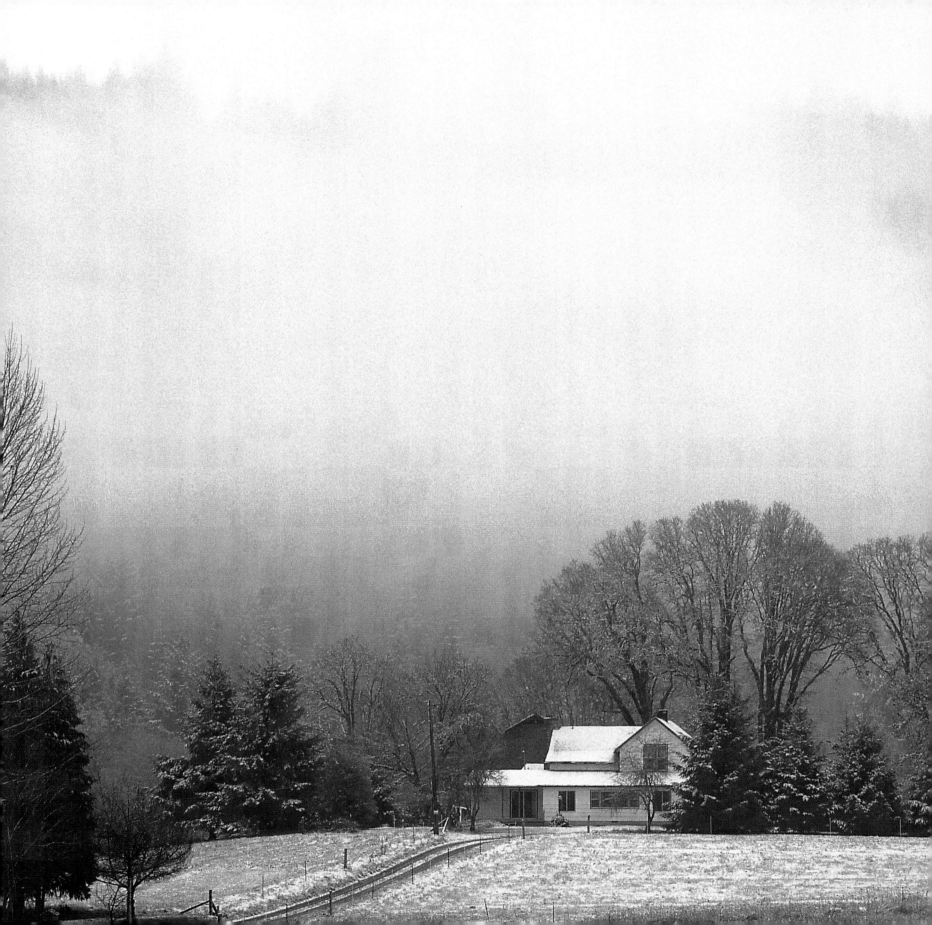

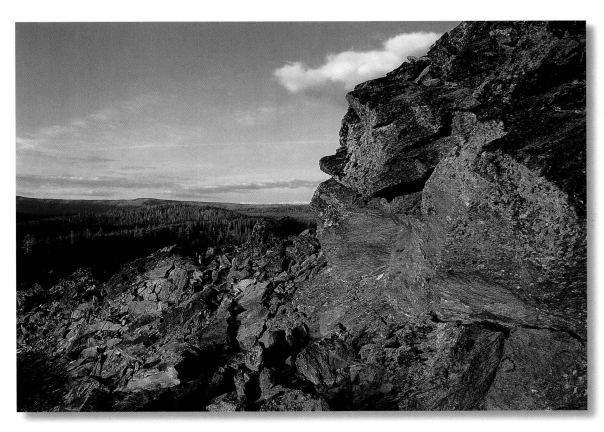

The 56,000-acre Newberry Volcanic National Monument was created in 1990, encompassing lava beds and mountain lakes left in the wake of eruptions about 1,300 years ago.

When visitors think of Oregon's climate, they often picture the rain- and storm-swept coast. But the state's mountains and inland plains receive their fair share of snow in the winter. In fact, Oregon has the longest lift-serviced ski season on the continent.

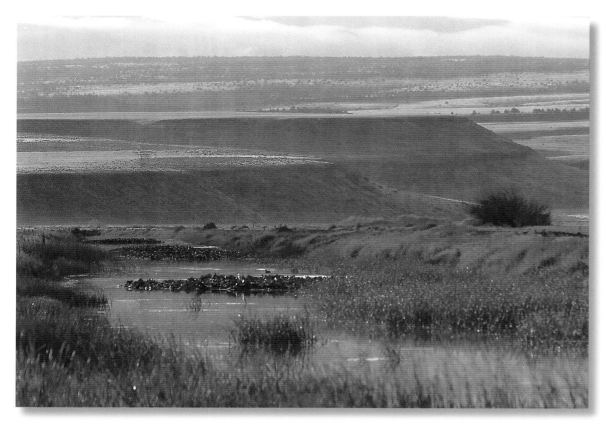

Malheur National Wildlife Reserve protects 184,000 acres and hosts more than 300 bird species, including trumpeter swans and sandhill cranes, during the spring and fall migrations.

The road that winds along the bottom of five-mile-long Leslie Gulch is a favorite access road for hikers. The surrounding cliffs are also a great place to watch for bighorn sheep.

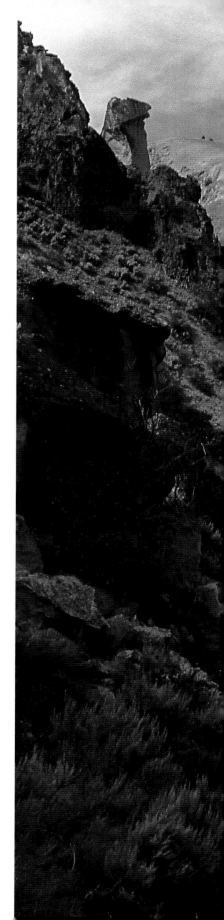

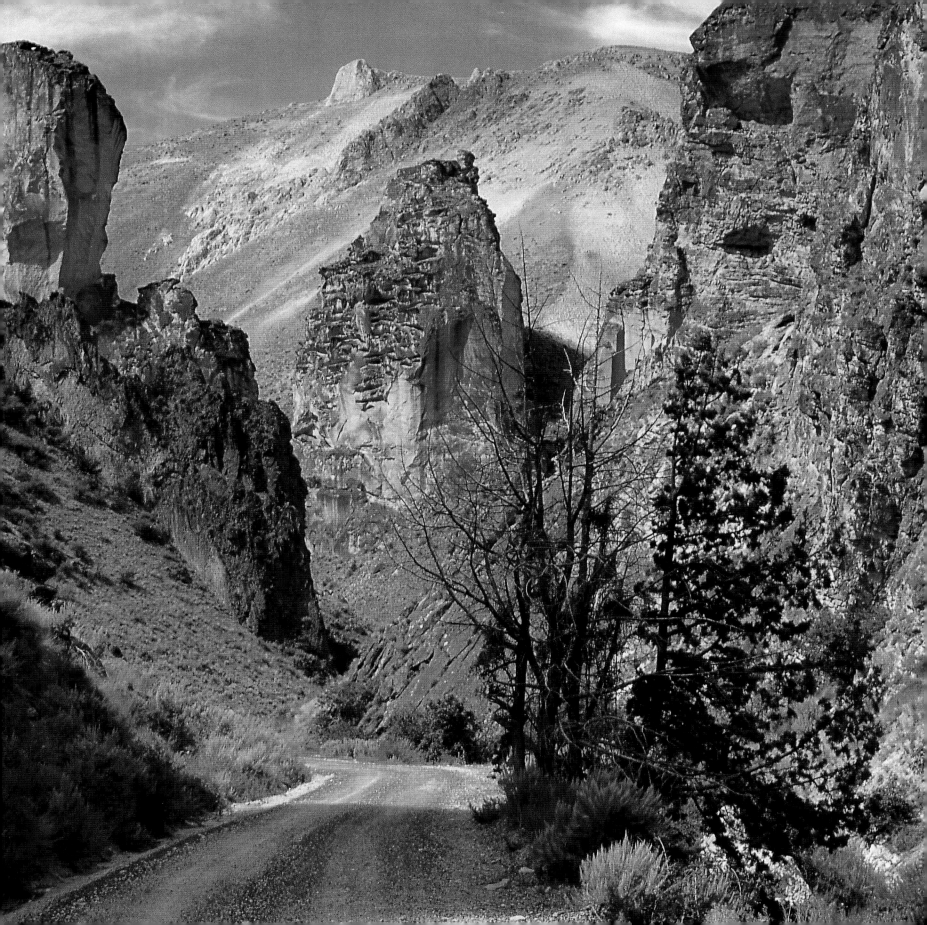

Many of Oregon's historical museums have a section dedicated to the tumultuous journey that more than 300,000 people faced traversing the Oregon Trail. They traveled from Missouri to Oregon in the 1800s in search of land for homesteading.

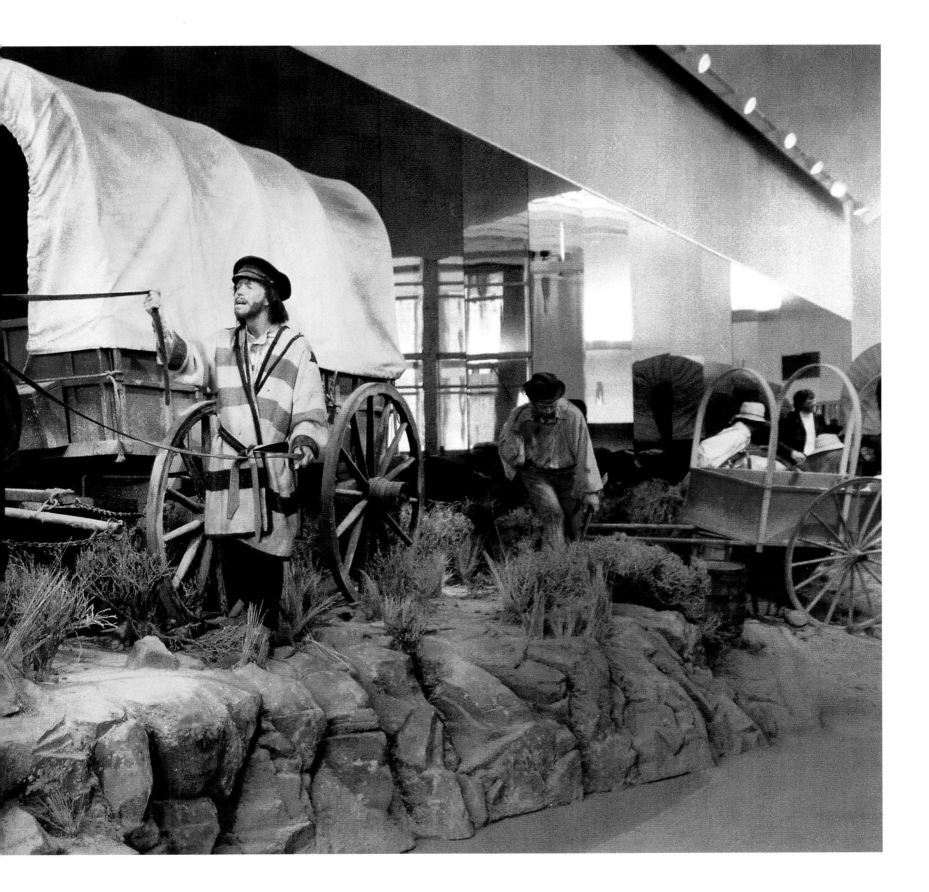

Visitors can walk a small section of the 2,000-mile Oregon Trail near where the original route crossed the Snake River.

OPPOSITE—
Hells Canyon on the Snake River is the deepest river-carved gorge in the country, varying from 5,600 to over 8,000 feet deep. Other gorges of this size were carved by glaciers.

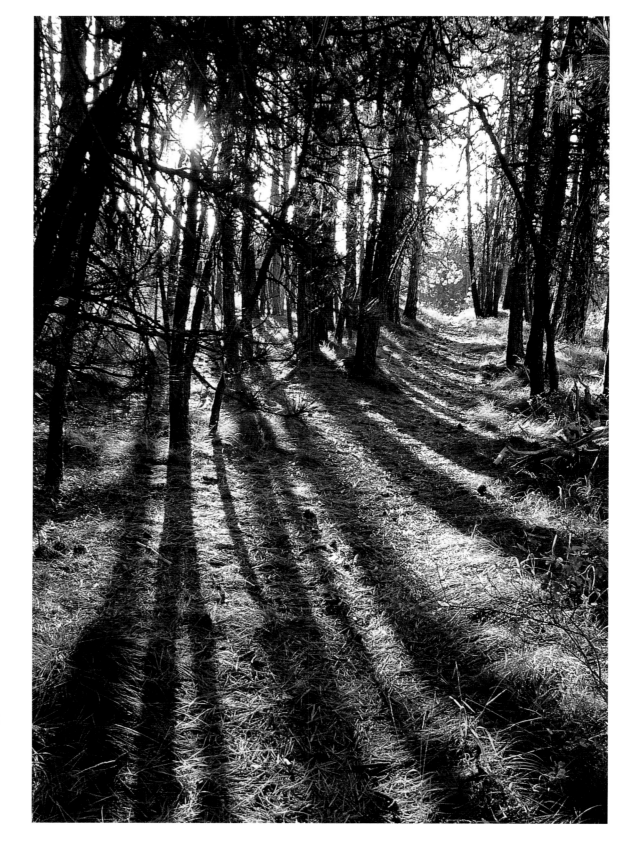

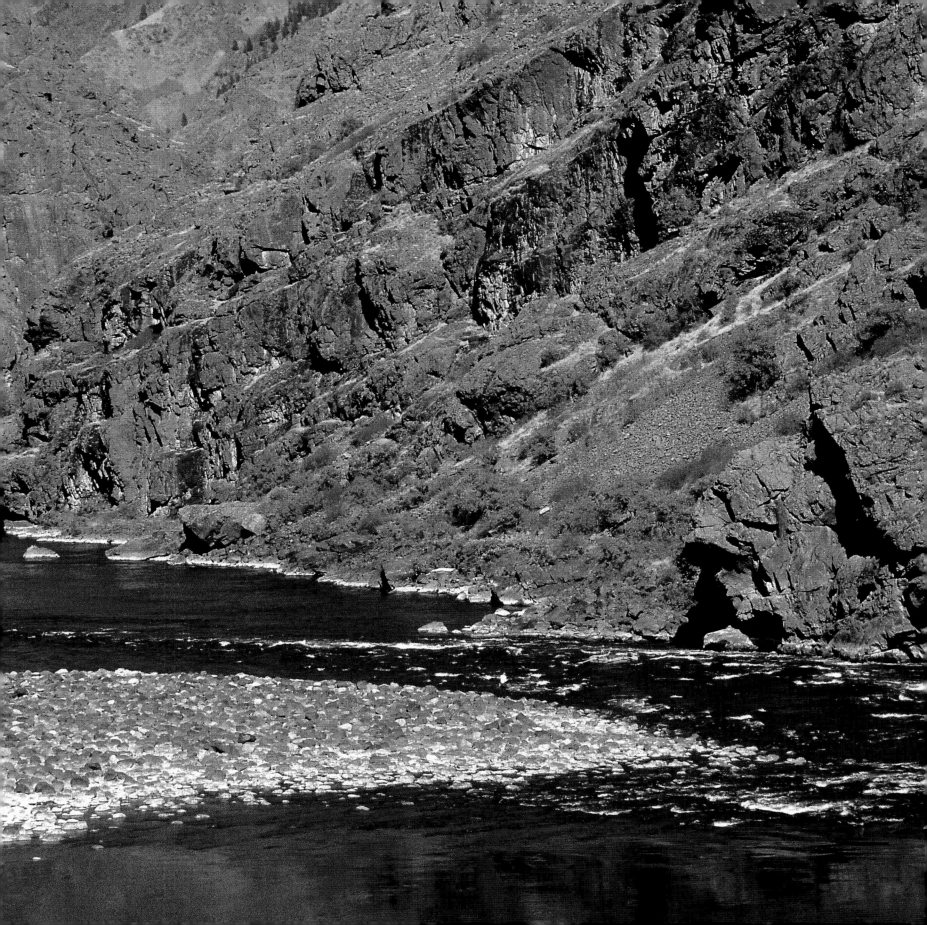

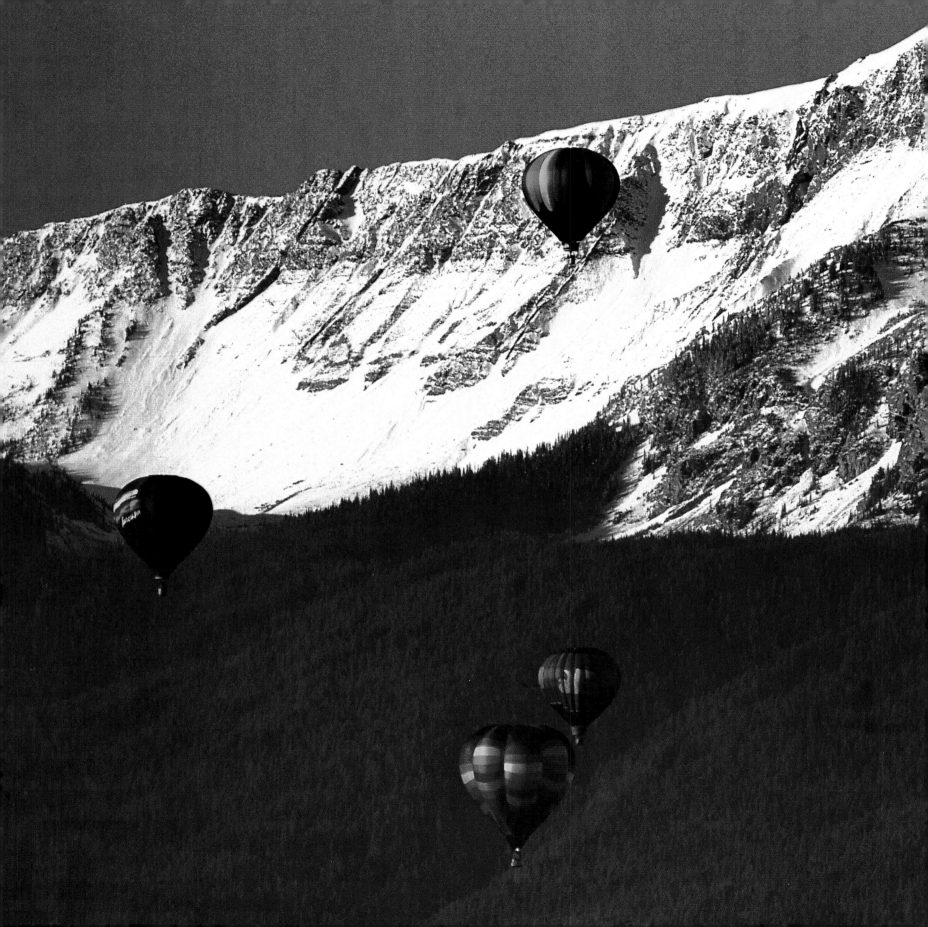

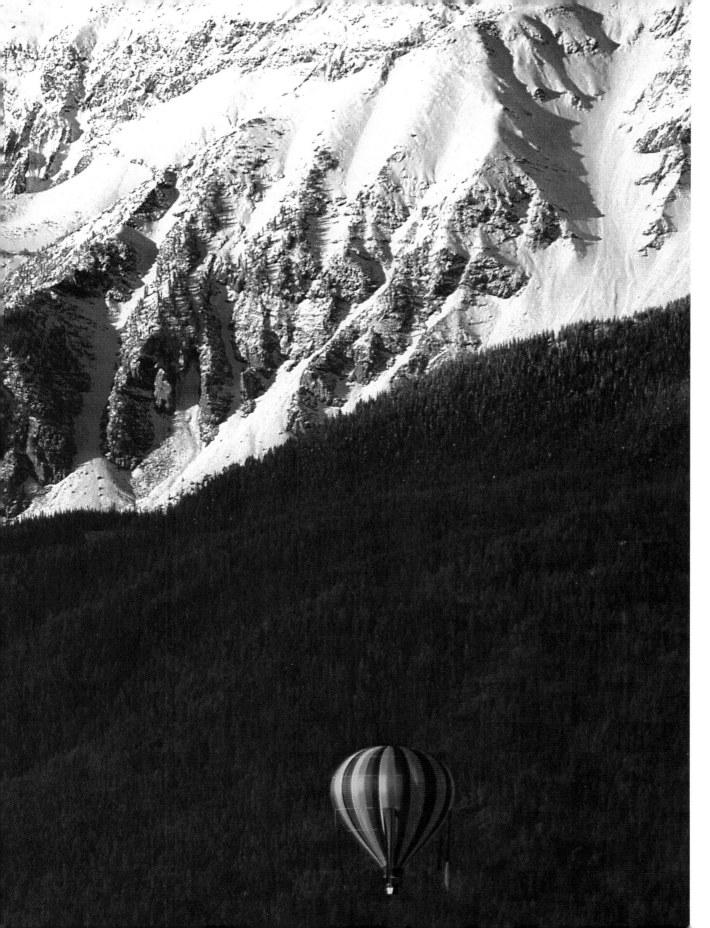

Hot-air balloons rise
over the slopes of the
Wallowa Mountains
near Enterprise.

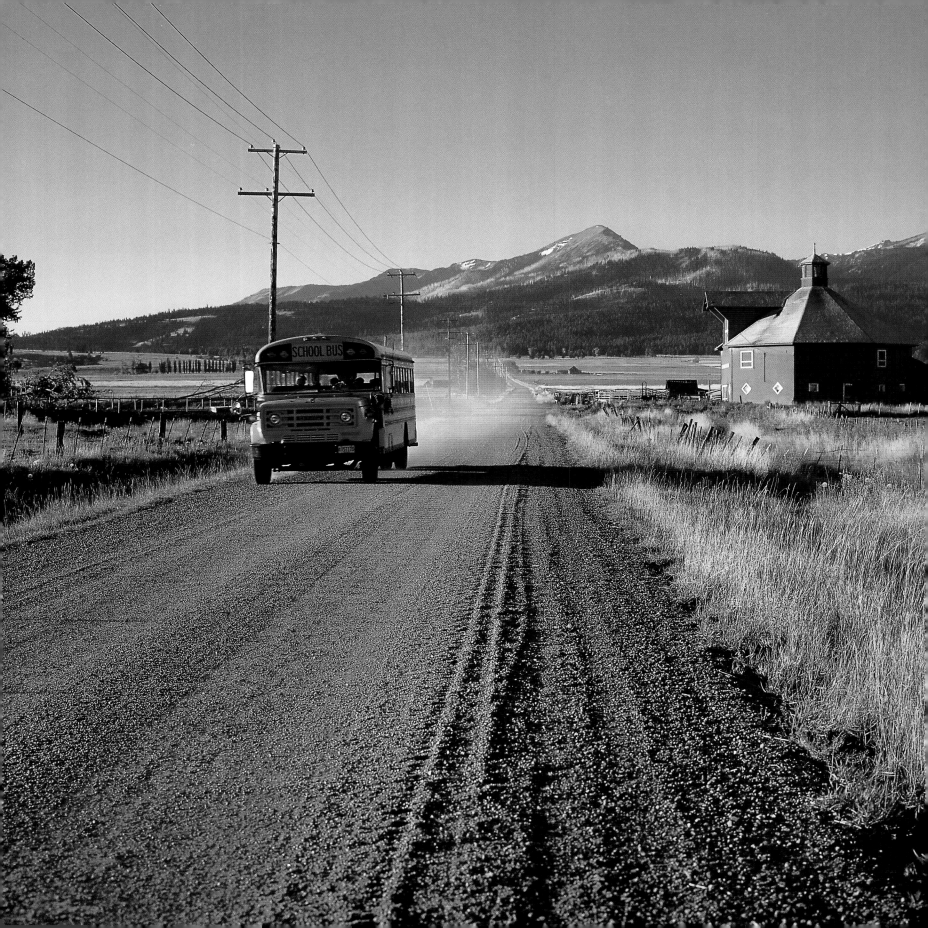

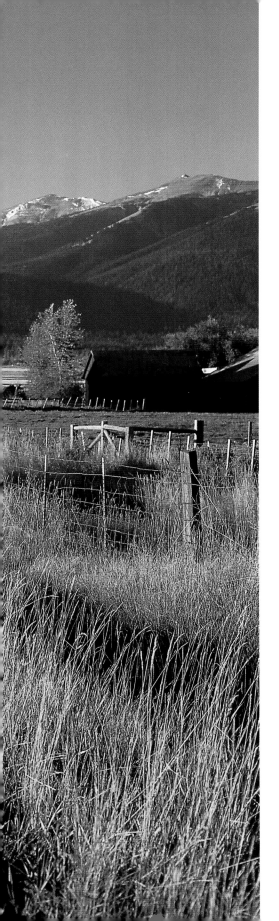

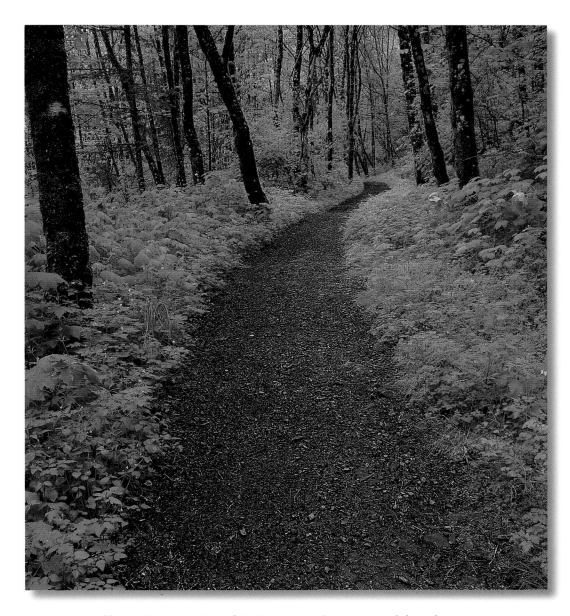

Oregon offers thousands of hiking trails. Some, like this one in John Yeon State Park, are short strolls. More experienced hikers can tackle the Pacific Crest Trail or the climb up Mount Hood.

Farms, cattle ranches, and lumber mills surround the town of Enterprise in the Wallowa Valley.

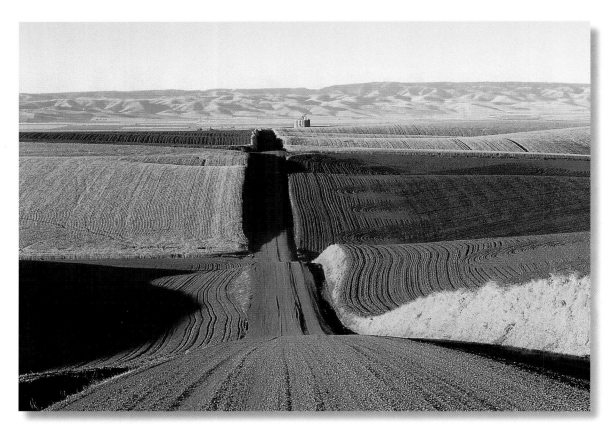

About 200 different crops, from wheat to peppermint, are grown in Oregon—more than in almost any other state.

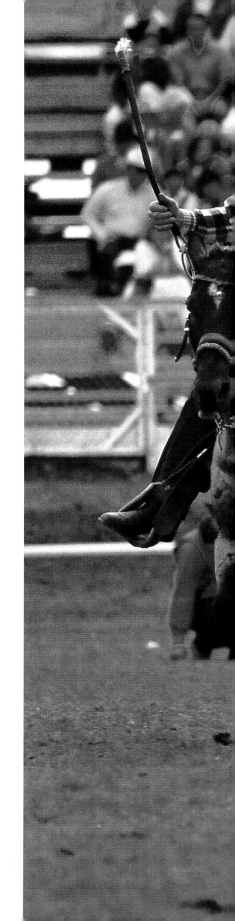

The Pendleton Round-Up has attracted growing audiences since its inception in 1910. The September celebration now draws as many as 90,000 spectators to its rodeo, parade, cowboy breakfast, and other Wild West events.

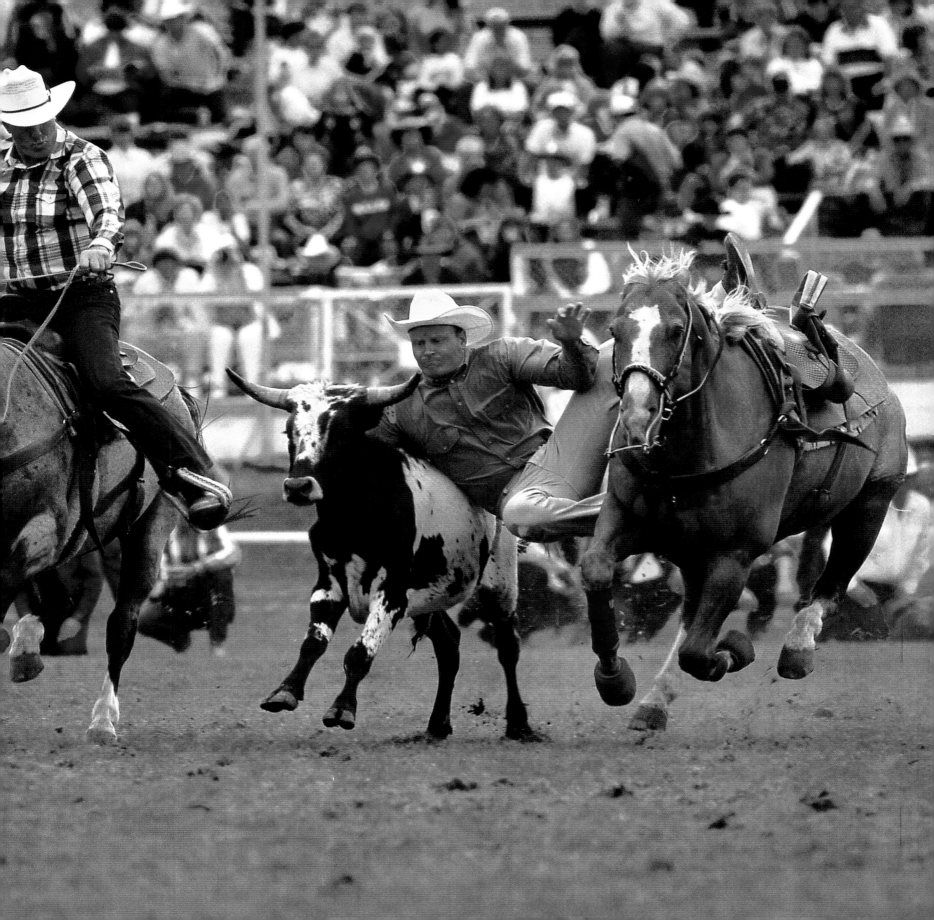

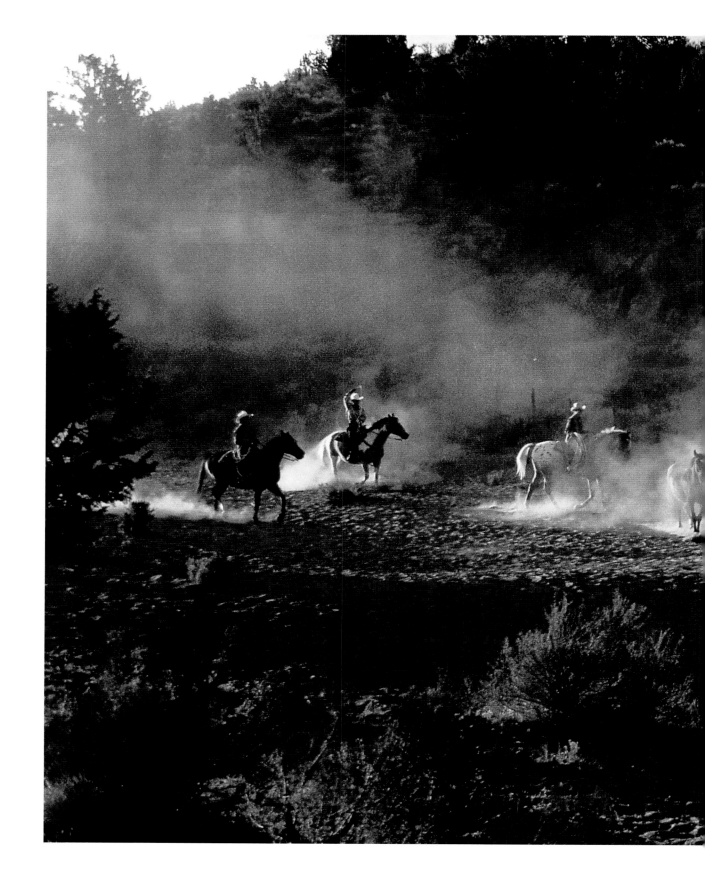

The high desert plateau of central Oregon, near Bend, is traditionally the stomping grounds of cowboys and ranch hands. The region is growing steadily more popular, however, as a base for skiing, golfing, rafting, and horseback riding.

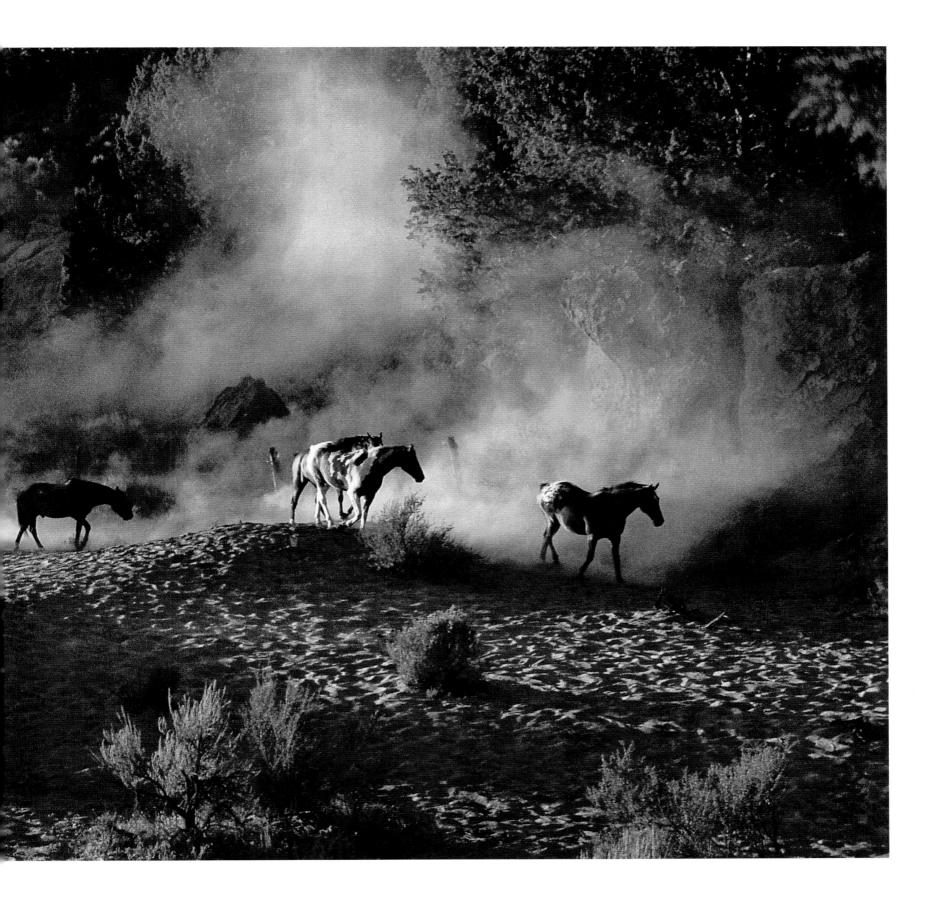

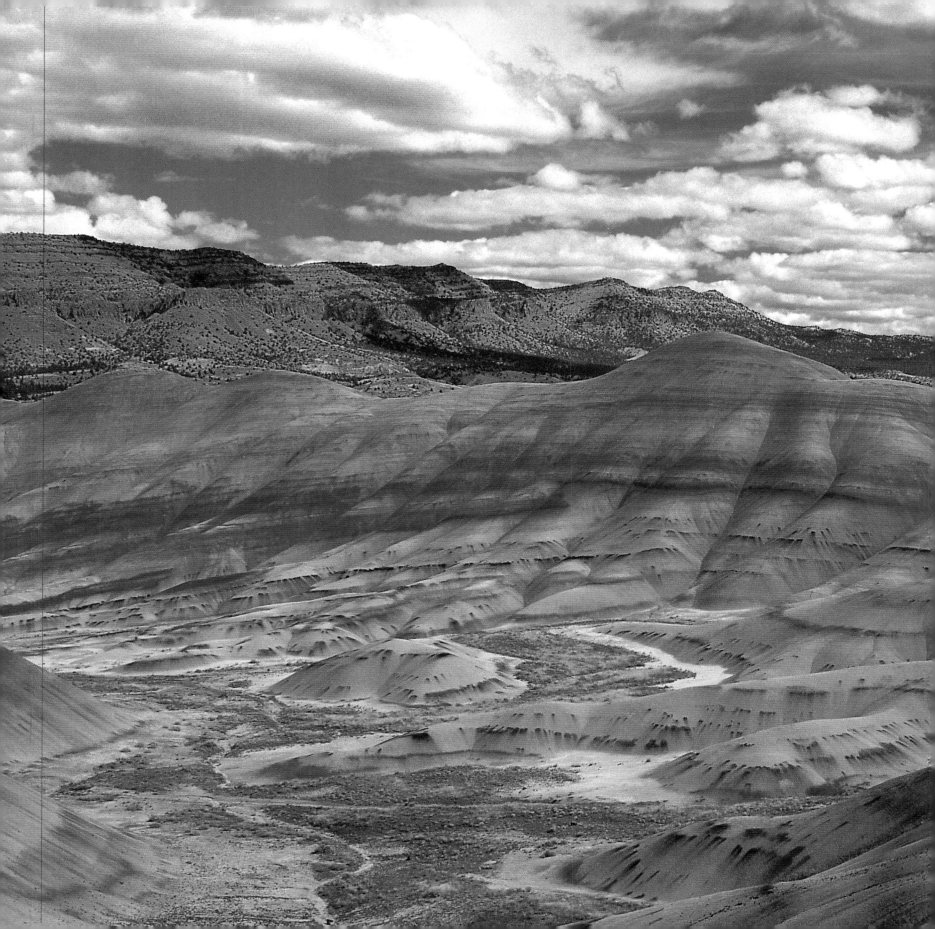

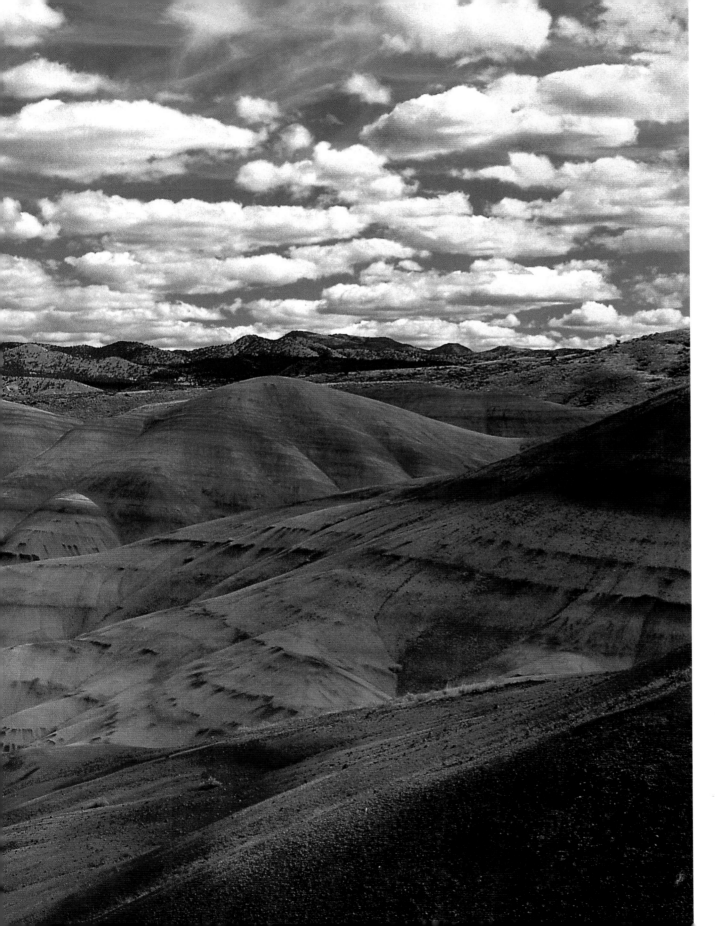

The Painted Hills
Unit of John Day
Fossil Beds National
Monument is one
of the state's most
photographed places.

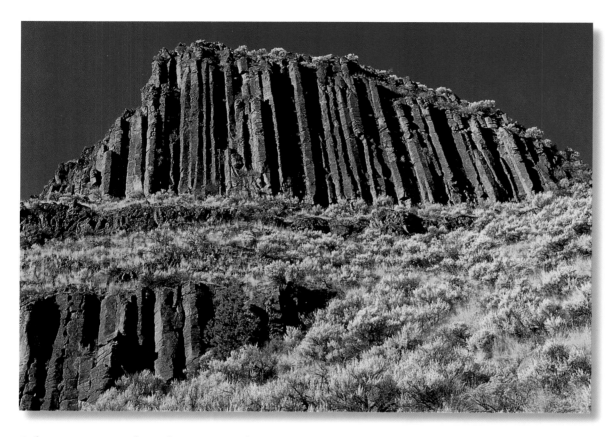

John Day Fossil Beds National Monument includes three areas totaling 14,000 acres of richly recorded history. Ancient volcanic soil has preserved the fossils of creatures from up to 45 million years ago, when this area was a lush subtropical region.

A walking path leads to a natural stone amphitheater in the John Day Fossil Beds.

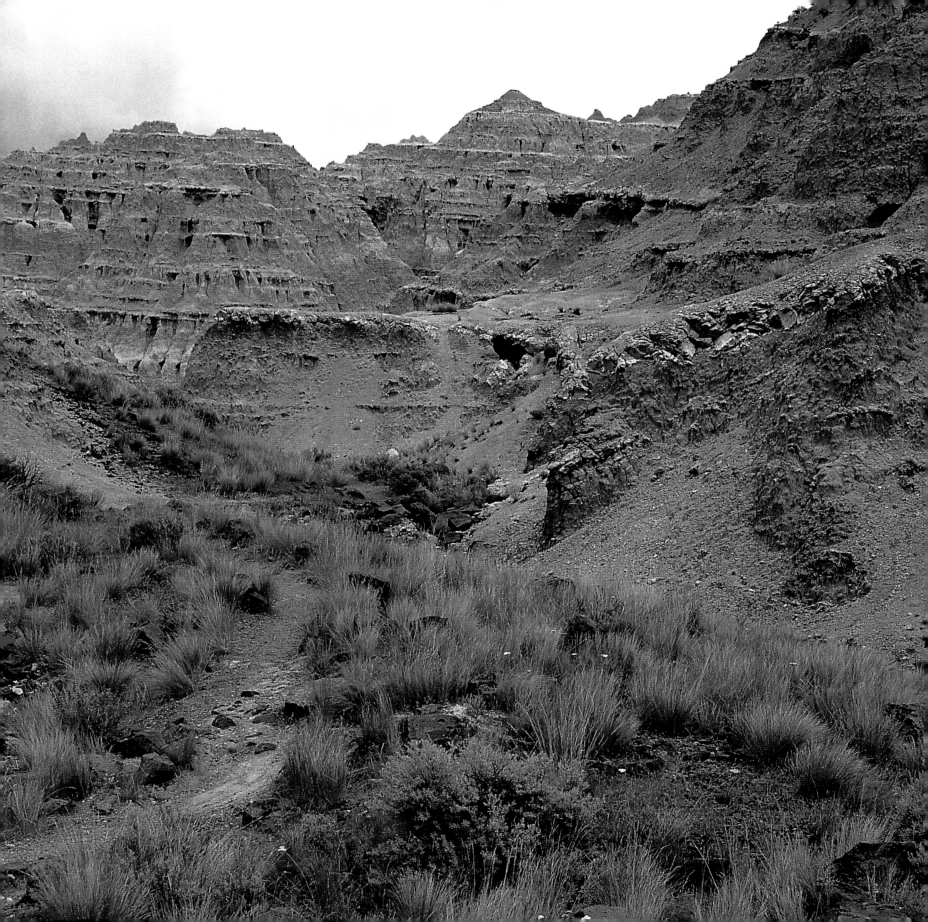

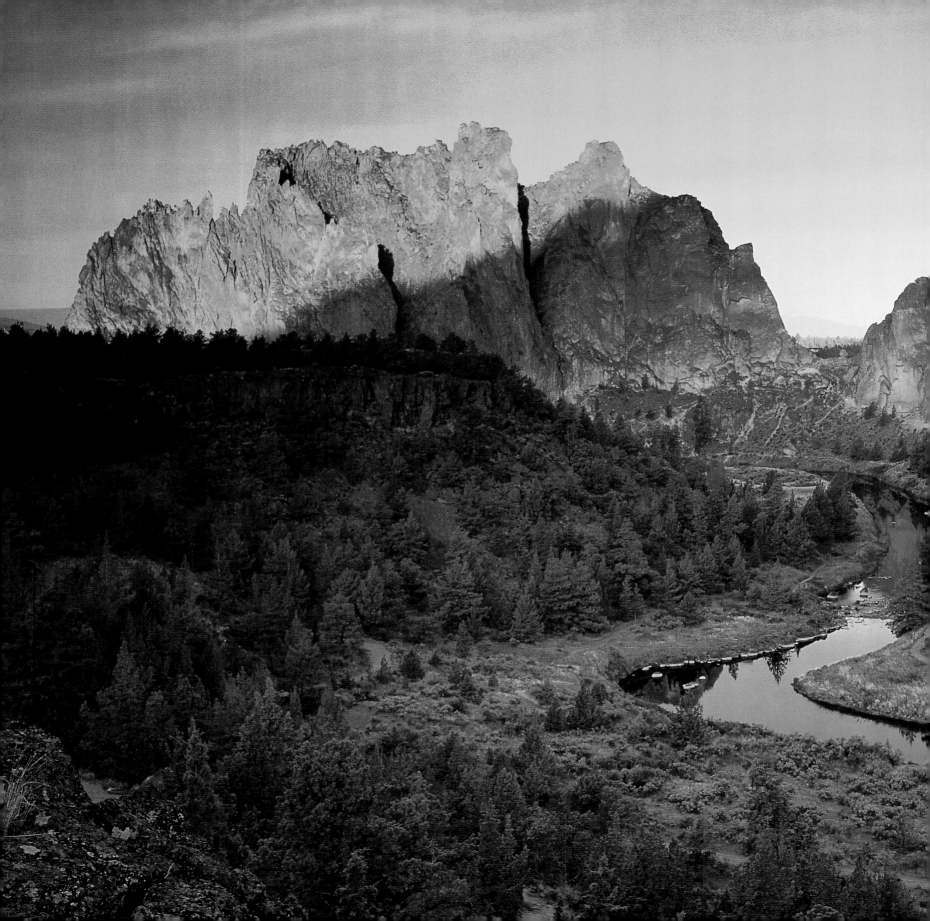

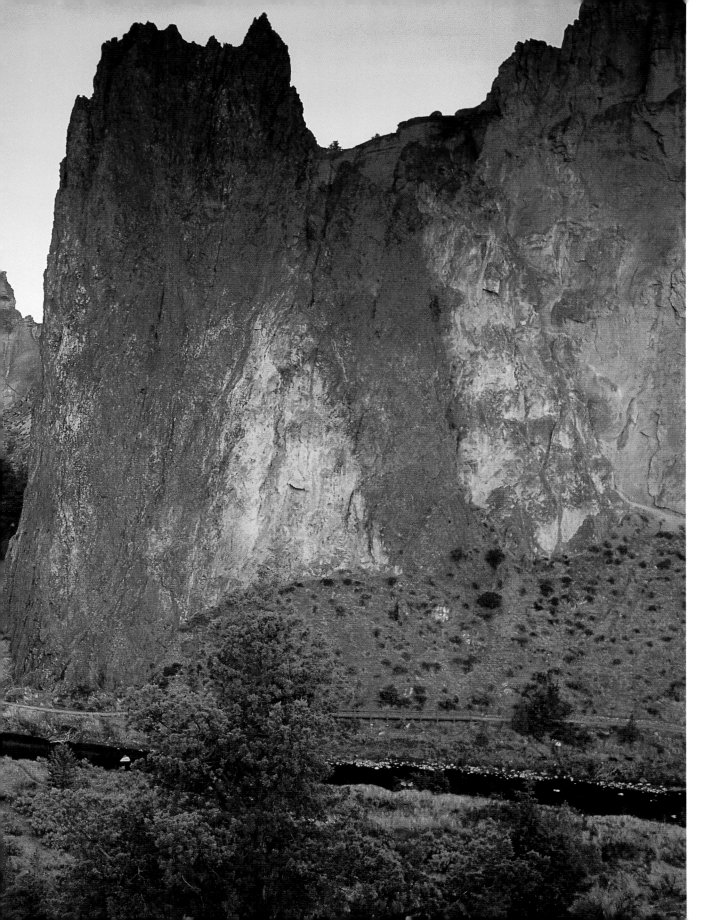

One of North America's most famous rock-climbing destinations, Smith Rocks State Park boasts thousands of climbing routes along with an extensive network of hiking and mountain biking trails.

The Crooked River Highway, Oregon Route 27, winds through scenic hills near Prineville. Although it is a state highway, the Crooked River route remains unpaved for 18.5 miles south of the Bear Creek Crossing.

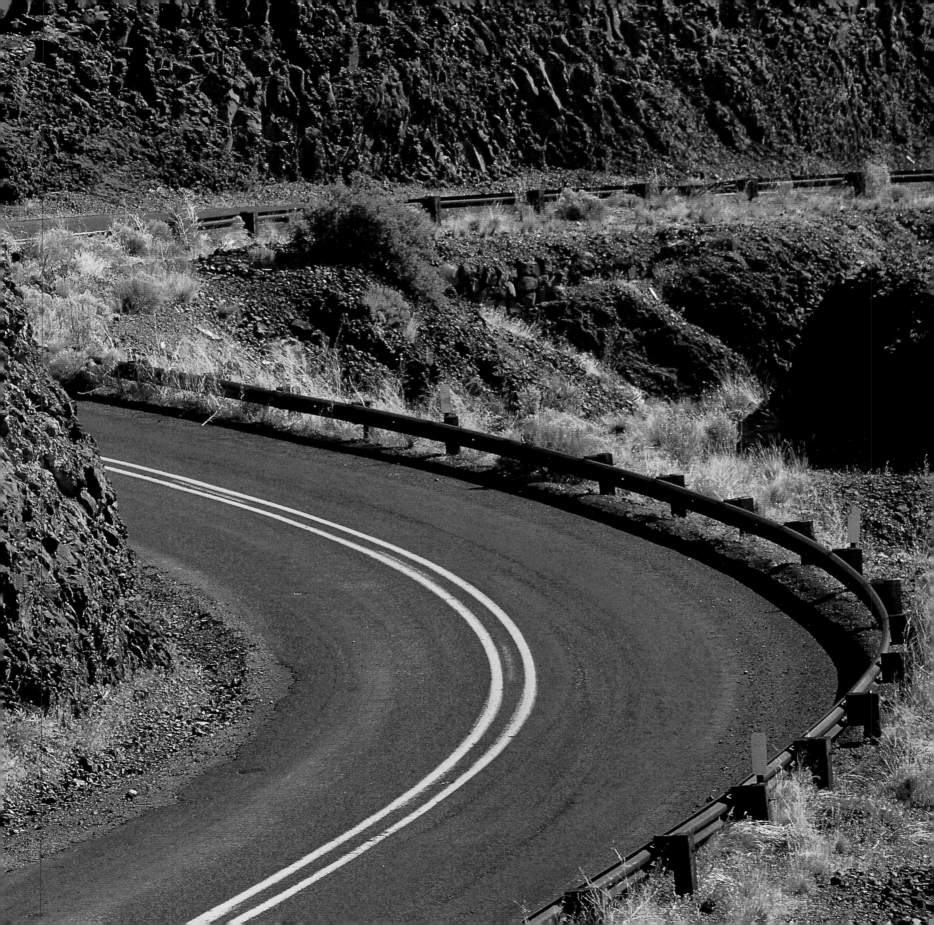

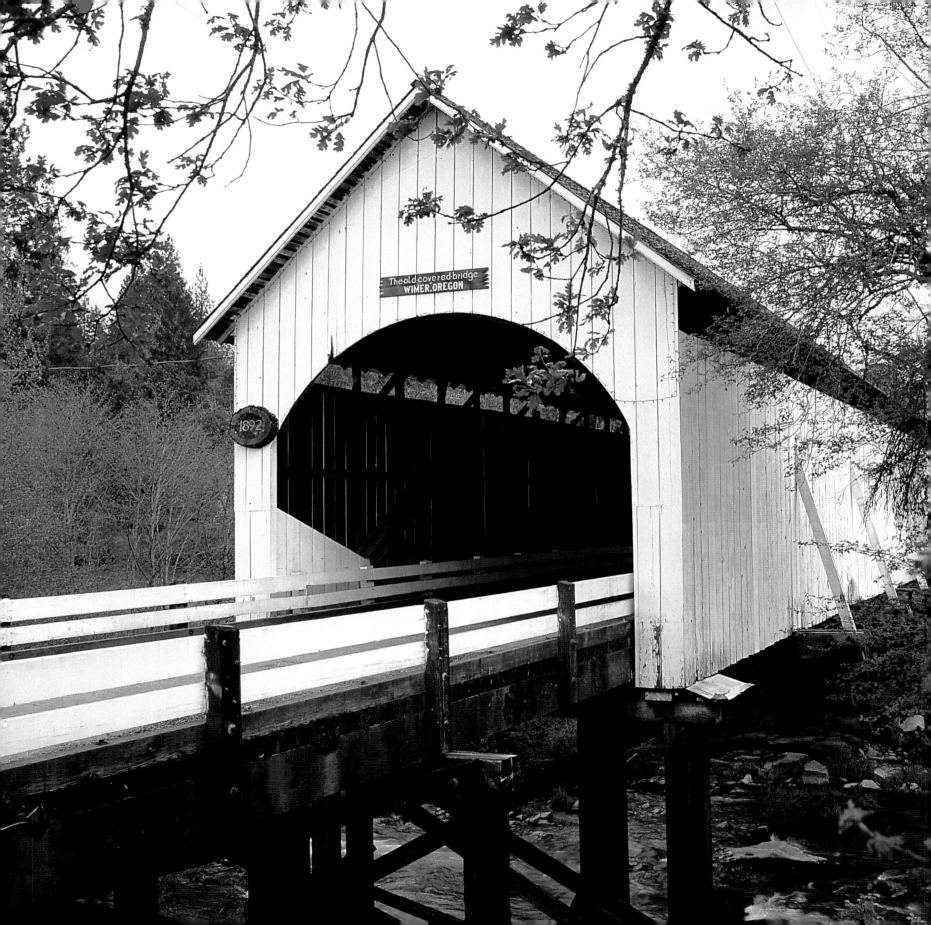

A worn post office marks one of Oregon's forgotten settlements. Most of these ghost towns, such as Sparta, Copperfield, Bourne, and Whitney, were once mining communities.

OPPOSITE—
Forty-eight covered bridges remain in Oregon, most in the Willamette Valley. Now quaint tourist attractions, the roofs were originally built to protect the wooden bridge decks from rain.

This young 4-H Club member gets a lesson in sheep farming. Oregon ranks eighth in the United States for its production of sheep and lambs.

OPPOSITE—
More than three million people live in Oregon, but only about a tenth of the population lives east of the Cascades. In fact, some of the state's agricultural regions are home to more cattle than people.

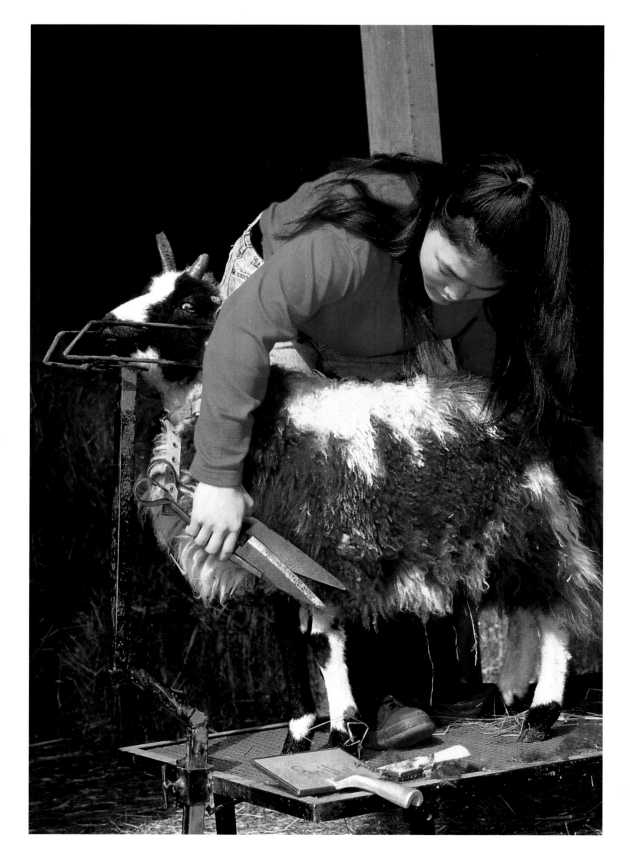

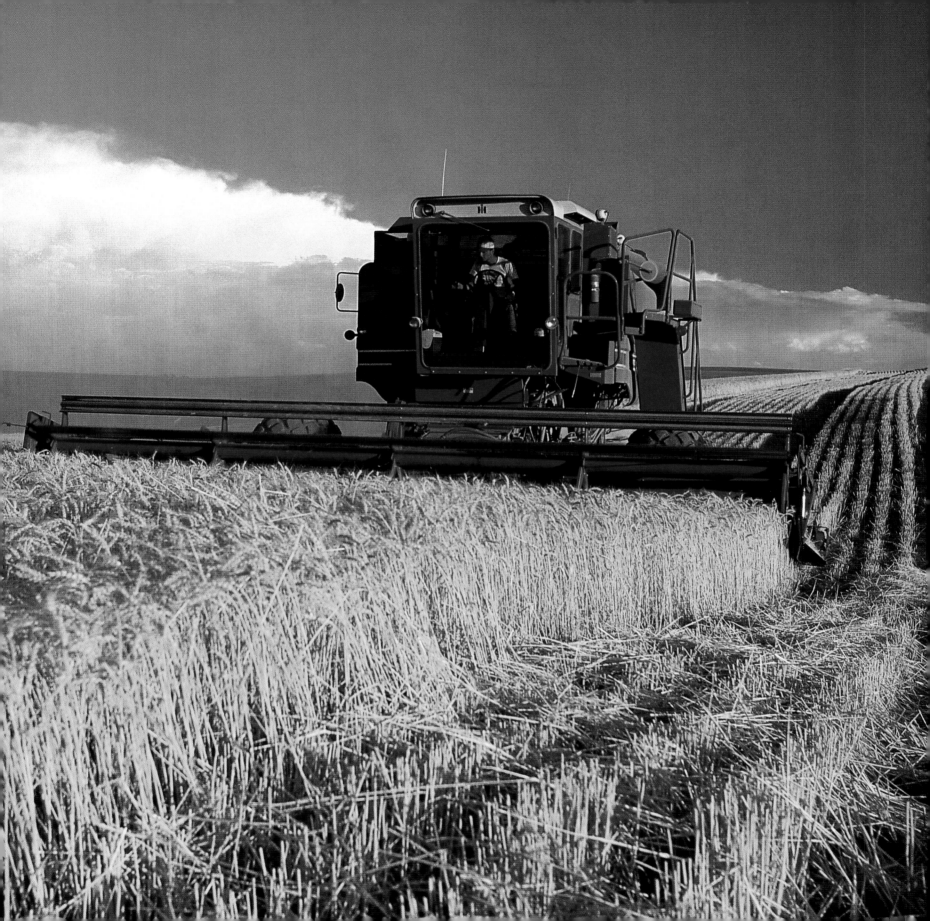

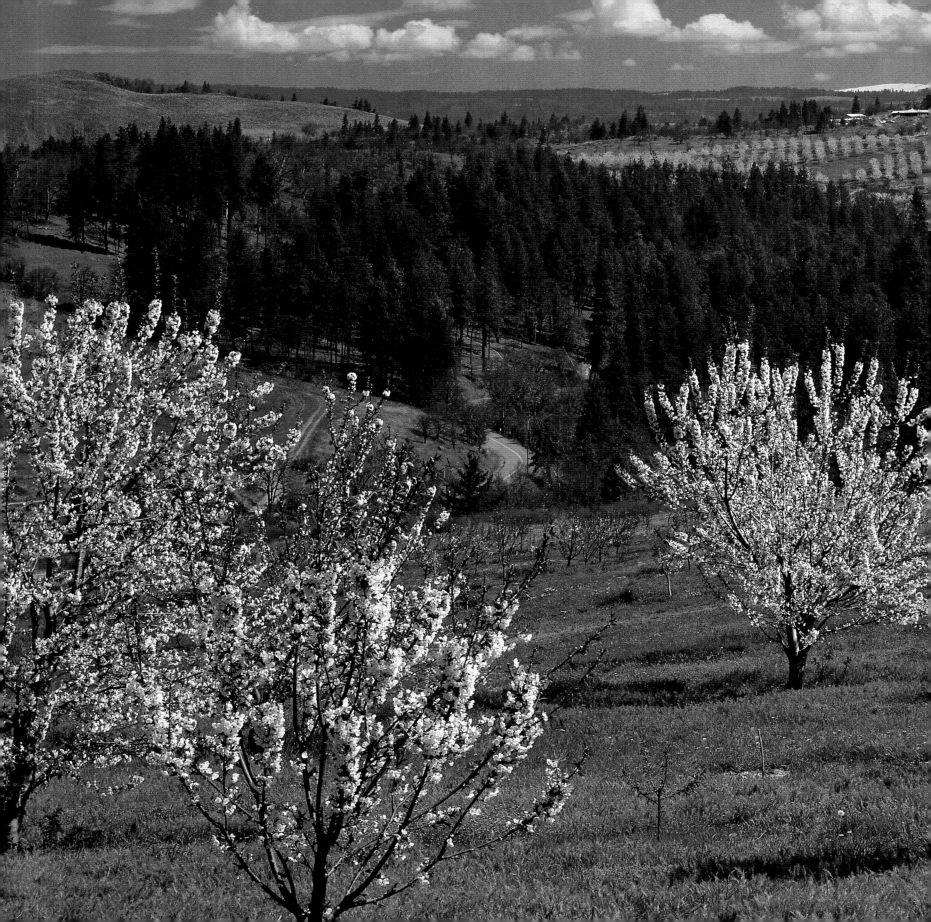

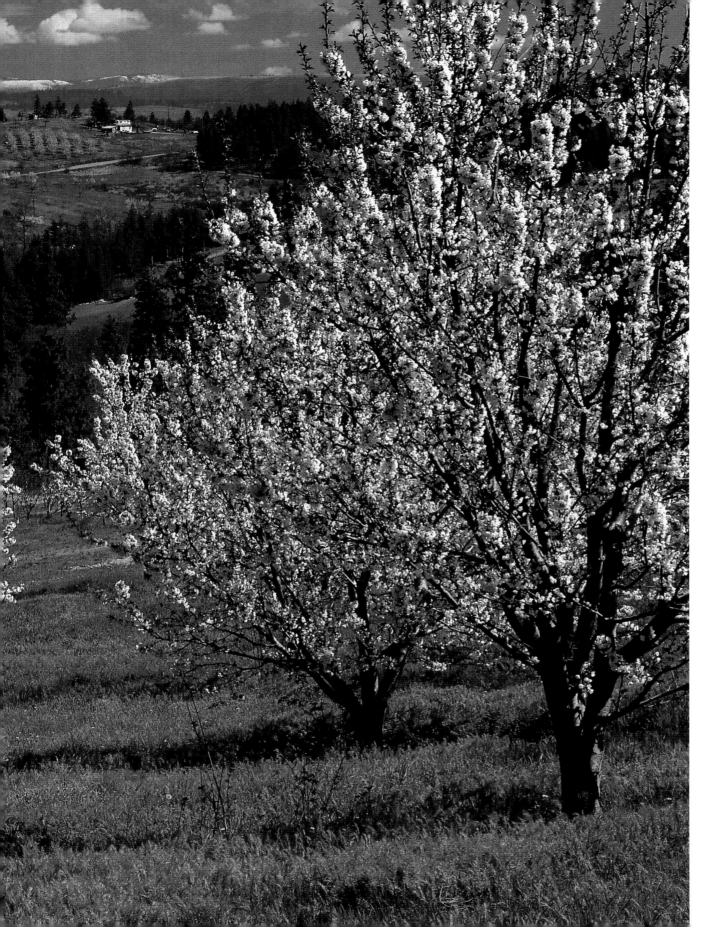

About 7.5 million fruit trees are grown on 47,500 acres of Oregon's farmland. Pears are the most common fruit tree. Cherries are the second most popular, grown on almost 12,000 acres.

Photo Credits

THOMAS KITCHIN / FIRST LIGHT 1, 3, 54–55

J. LOTTER GURLING / FIRST LIGHT 6–7, 9

B. ROSS / FIRST LIGHT 8

GREG VAUGHN / FIRST LIGHT 10–11, 23, 26–27, 45, 70–71, 72, 73

MARK AND LESLIE DEGNER 12, 28, 44, 47, 48–49, 64–65, 77

MARK TURNER 13, 52, 56, 57, 59, 63, 68, 85, 90, 91

BOB POOL / FIRST LIGHT 14, 15, 29, 34, 36–37, 76, 78, 79, 80–81, 92

RON WATTS 16–17, 19, 30, 35

© TIM MARKLEY / ISTOCKPHOTO.COM 18

JOHN GRESS 20–21

BRETT PATTERSON / FIRST LIGHT 22

DAN SHERWOOD 24–25, 38, 39, 40–41, 74–75

STEVE SHORT 31, 46, 53

ROBERT LANDAU / FIRST LIGHT 32–33

DARWIN WIGGETT 42–43, 88–89

LYNN STONE 50

NATALIE CHAPMAN 51

© LARRY ULRICH 58

STEVE SHORT / FIRST LIGHT 60–61

BRIAN MILNE / FIRST LIGHT 62

P. McLEOD / FIRST LIGHT 66

TERRY DONNELLY / FIRST LIGHT 67, 94–95

MILTON RAND / FIRST LIGHT 69

RON WATTS / FIRST LIGHT 82–83

DARWIN WIGGETT / FIRST LIGHT 84, 86–87

INGA SPENCE / FIRST LIGHT 93